Contents

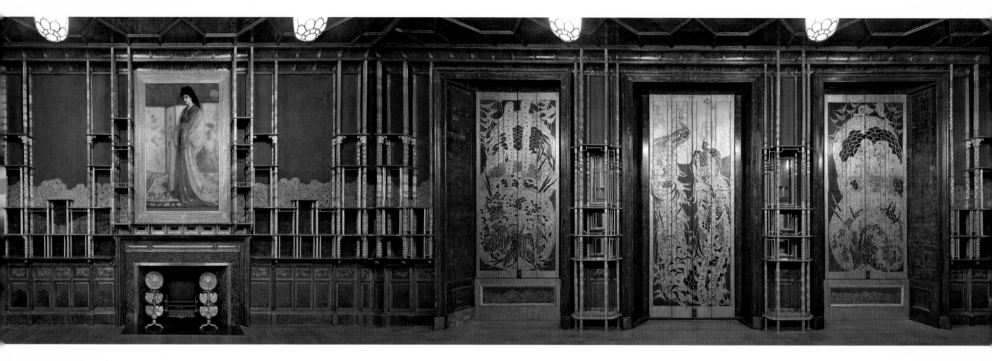

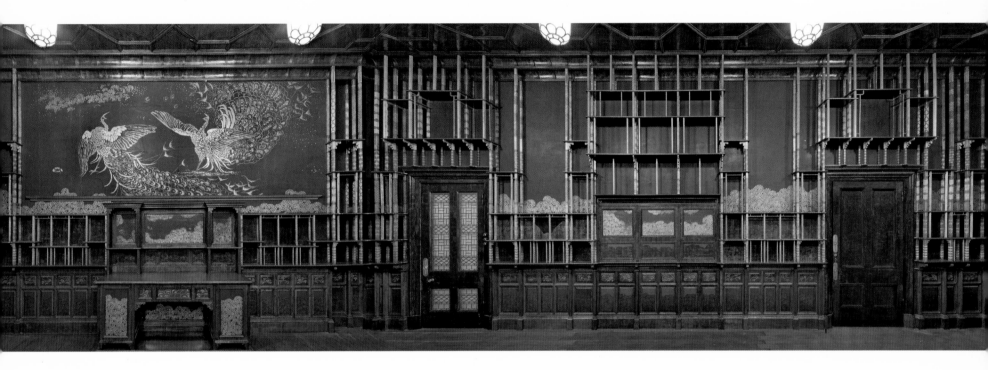

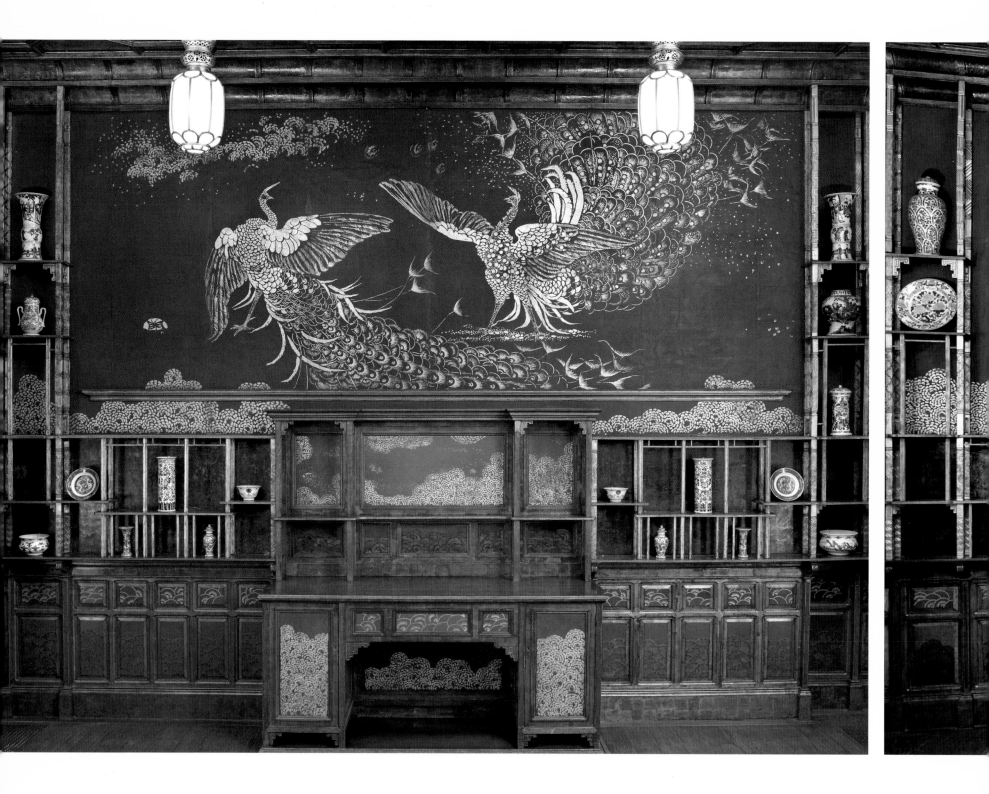

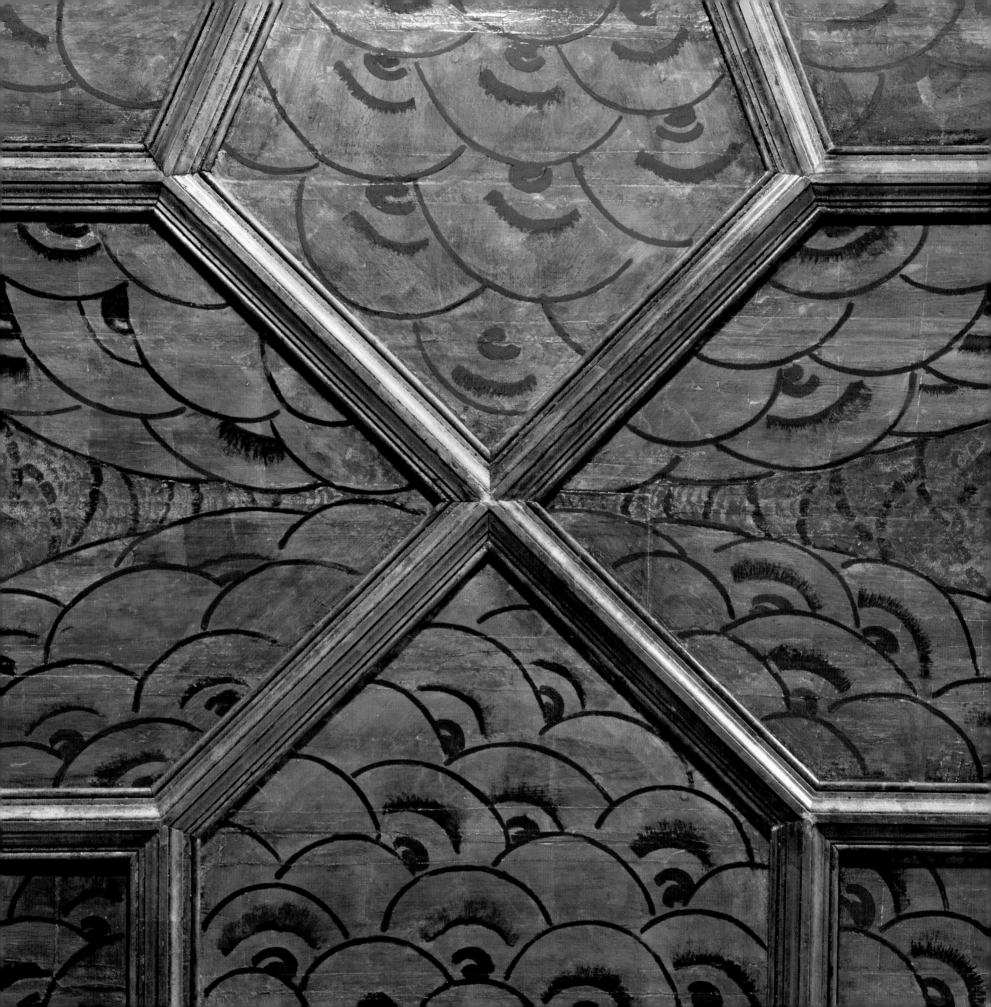

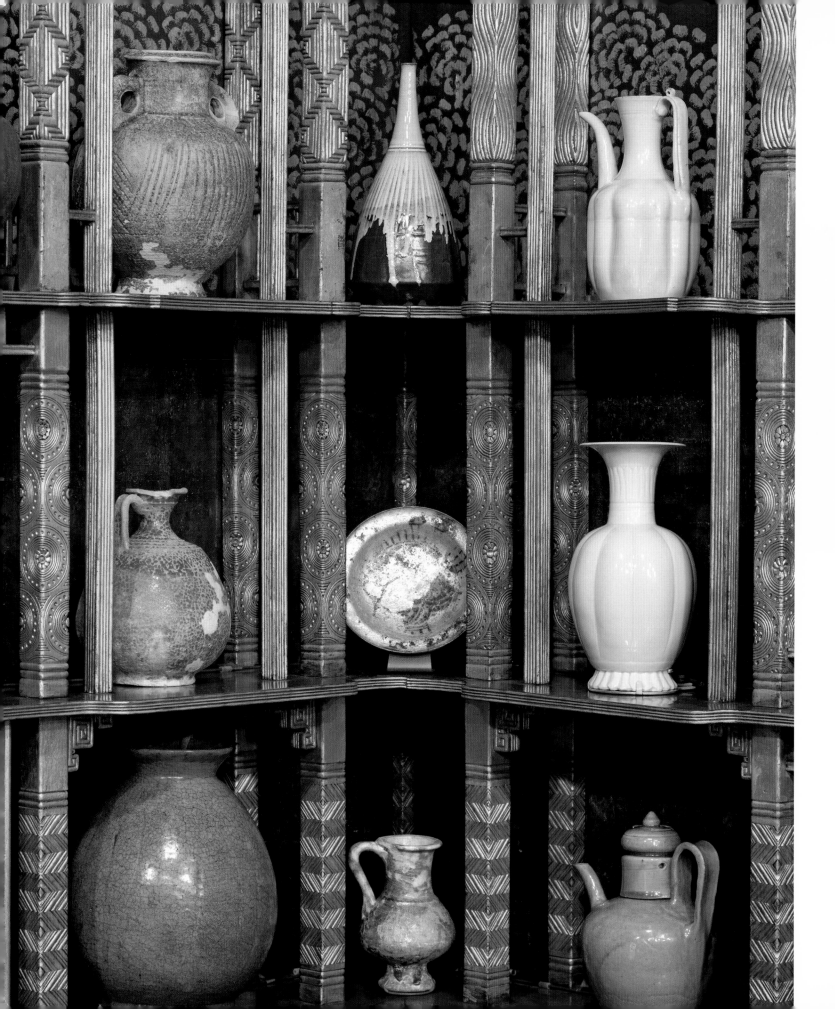

The Peacock Room
Comes to America

Lee Glazer

Freer Gallery of Art, Smithsonian Institution
Washington, D.C.

Published by the Freer Gallery of Art and the Arthur M. Sackler Gallery on the occasion of the exhibition *The Peacock Room Comes to America*, which opened April 9, 2011.

Front cover: South wall of the Peacock Room
Front and back inside covers: Detail of paneled ceiling with peacock feather pattern
Title page: Detail of northeast wall
Right: Detail of gilded lattice work designed by Thomas Jeckyll
Pages 2–3: Panorama of Peacock Room with empty shelves, prior to 2011 reinstallation
Pages 4–5: South and north walls as they appeared 1993–2011
Back cover: Detail of south wall of the Peacock Room

Head of Design and Production: Karen Sasaki
Editor: Nancy Eickel
Catalogue Design: Adina Brosnan McGee
Image and Photo Services: John Tsantes

Typeset in Benton Sans and Sabon
Printed by Todd Allen, Beltsville, MD

Library of Congress Cataloging-in-Publication Data
Freer Gallery of Art.
 The Peacock Room comes to America / Lee Glazer.
 pages cm
 Published by the Freer Gallery of Art and the Arthur M. Sackler Gallery on the occasion of the exhibition The Peacock Room Comes to America, which opened April 9, 2011
 ISBN 978-0-934686-20-4 (pbk.)
 1. Peacock Room--Exhibitions. 2. Freer, Charles Lang, 1854-1919--Aesthetics--Exhibitions.
 3. Art, Asian--Collectors and collecting--United States. 4. Art--Washington (D.C.)--Exhibitions.
 5. Freer Gallery of Art--Exhibitions. I. Glazer, Lee (Lee Stephens) II. Title.
 ND237.W6F74 2012
 747.7--dc23
 2012008047

FREER | SACKLER
THE SMITHSONIAN'S MUSEUMS OF ASIAN ART

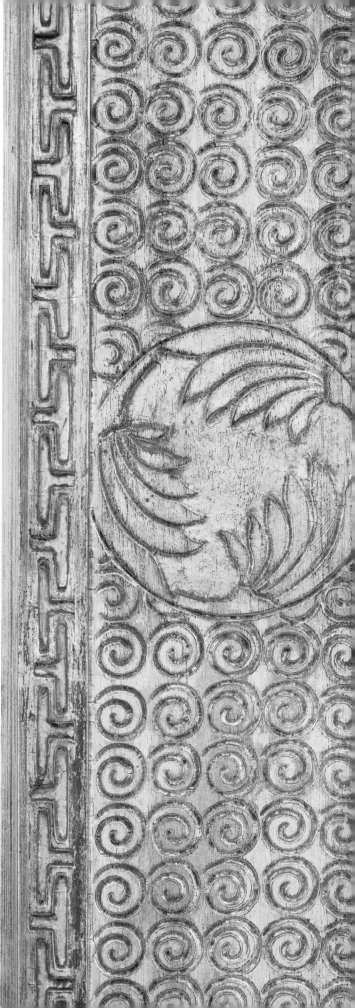

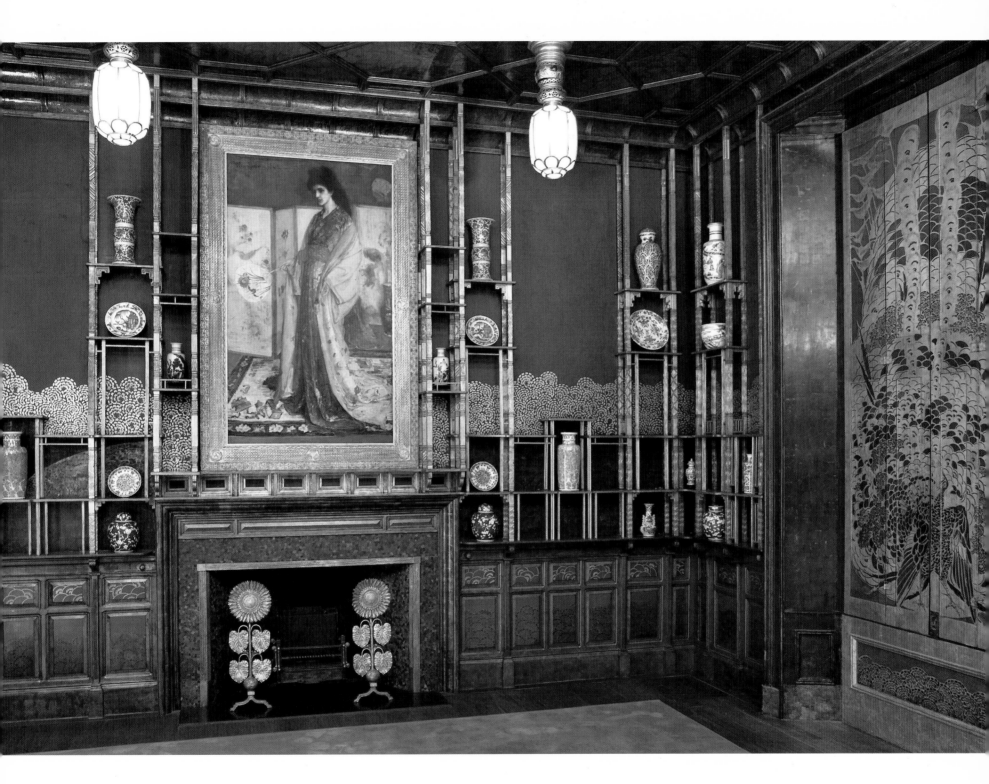

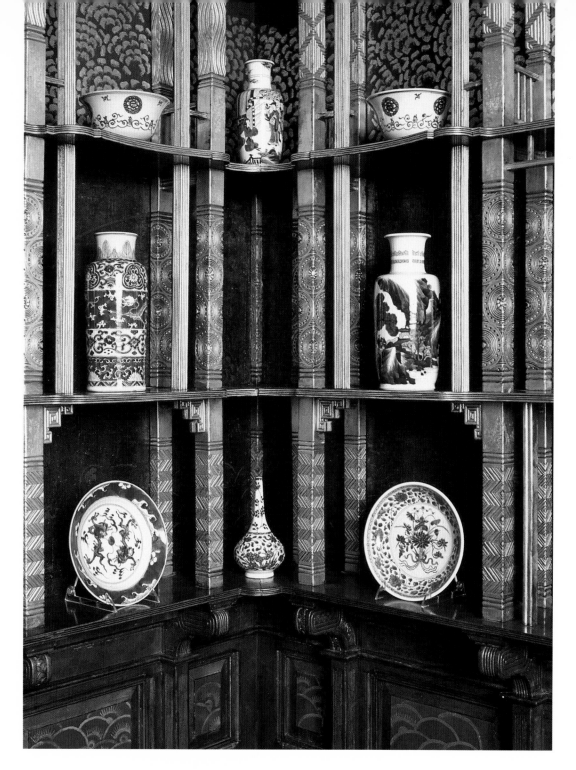

ABOVE
Northeast corner installed with blue-and-white
Kangxi porcelain, prior to 2011

TOP RIGHT
Thomas R. Way, *Portrait of Whistler*, 1879

BOTTOM RIGHT
James McNeill Whistler, *Arrangement in Black:
Portrait of F. R. Leyland*, 1870–73

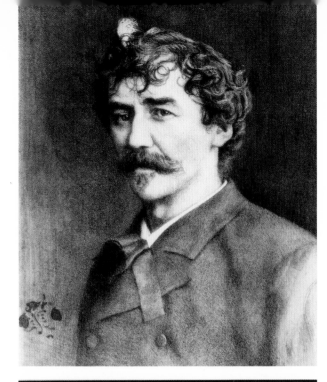

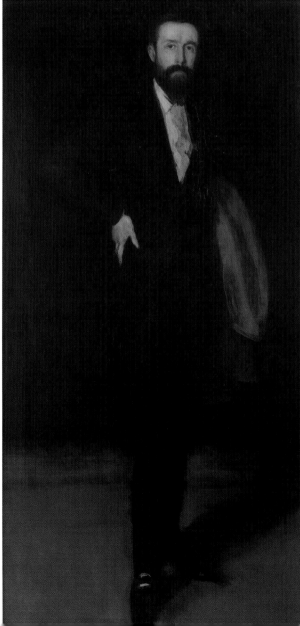

The Peacock Room
Comes to America

The Peacock Room, the renowned interior decoration by American expatriate artist James McNeill Whistler, has had a dynamic history. Its story began simply enough, when a Victorian shipping magnate decided to use the space to showcase his collection of Chinese ceramics. The narrative took an unexpected turn when an American artist was consulted on suitable room colors, and its legacy was secured when an art collector from Detroit brought the Peacock Room to America.

Originally it was the dining room in the London mansion of ship owner Frederick Leyland (1832–1892) from Liverpool. Leyland wanted to transform his home in the Kensington section of London into a palace of art, and he hired architect Thomas Jeckyll (1827–1881) to design the room and its lattice shelves to display an extensive collection of blue-and-white Kangxi porcelain. Jeckyll asked Whistler (1834–1903) for advice on an appropriate color scheme for the door. Inspired by the delicate patterns and vivid colors of the ceramics on display, Whistler entirely redecorated the room in 1876 and 1877 as a "harmony in blue and gold." The room's final brilliance was more than Leyland had anticipated, and he and Whistler were soon locked in a bitter, prolonged quarrel. After completing his work, Whistler never saw the Peacock Room again.

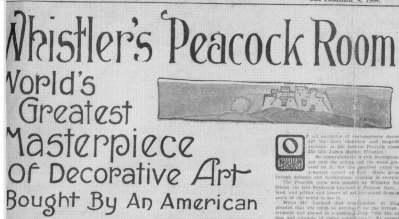

The Chicago Sunday Tribune.

SEPTEMBER 4, 1904.

Whistler's Peacock Room
World's Greatest Masterpiece Of Decorative Art
Bought By An American

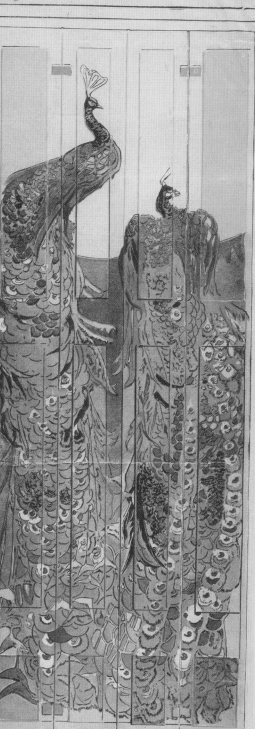

OF all examples of contemporary decorative art the most elaborate and magnificent, perhaps, is the famous Peacock room by the late James McNeil Whistler.

So comprehensive is this decoration that not only the ceiling and the walls are covered by it, but the smallest panel in the remotest corner as well. Rich, gorgeous, though delicate and harmonious, coloring is everywhere.

The Peacock room was painted by Whistler for his friend, the late Frederick Leyland of Prince's Gate, England, and critics and lovers of art journeyed from many parts of the world to see it.

When Mr. Leyland died connoisseurs in England pleaded that the room be purchased by the British government and placed in a public gallery "for the education and pleasure of rising generations." To permit the room to fall into the hands of an individual, they argued, would be cause for patriotic grief.

Purchased by an American.

While this matter was being discussed Charles L. Freer, a multi-millionaire of Detroit, stepped in and purchased the decoration, paying about $60,000 for it. So, much to the anger and disappointment of the English critics, it not only has fallen into the hands of an individual, but will be shipped out of the country to America as well.

Mr. Freer is perhaps better known in Europe than in this country as the owner of one of the finest libraries of rare editions in the world. For many years, while he was associated with the late Senator James McMillan of Michigan, with whom he accumulated a great portion of his wealth, Mr. Freer spent all the time he could spare in traveling abroad picking up books. His rambles as a bibliophile brought him into companionship with dealers in paintings, with critics, and with the artists themselves. In this way he came to meet Whistler, whom he considered one of the foremost masters. Mr. Freer began by buying his pictures whenever opportunity presented itself. Then he commissioned him to paint on order until his collection of works by Whistler is said to be unsurpassed.

Knowing the artist intimately—a rare privilege, for Whistler was reserved almost to eccentricity—what could be more natural than that he should long to get possession of all his works? Especially was Mr. Freer desirous of obtaining the remarkable Peacock room, his intention being to move it across the Atlantic to embellish his mansion in Detroit.

Whistler Objects to Picture's Setting.

The origin and development of the Peacock room quite befitted Whistler's peculiar temperament. Probably no great modern work of art has so unique a history.

The late Frederick Leyland was an Englishman possessing a palatial house filled with the best examples of Burne-Jones, Rossetti, Ford Madox Brown, and other modern masters. Indeed he was an admirer of Whistler, he purchased the celebrated "La Princesse du Pays de la Porcelaine," by him, and placed it over the mantelpiece of his dining room. This room was beautifully ceiled and paneled in wood by the well known architect Jeckyll, who had carte blanche as to cost and arranged its color scheme to harmonize with Mr. Leyland's fine collection of Nankin porcelain and with Whistler's painting. One day at luncheon, as Mr. Leyland's guest, Whistler remarked that the design of the room and his picture did not go well together, they lacked harmony, he said.

Decorates Room to Match Painting.

Although quite satisfied with the room up to that, Mr. Leyland was much impressed by Whistler's criticism. In fact, it grew upon him until he really became distressed. Finally he commissioned the artist to decorate the room to fit the picture.

Whistler entered upon his task with his entire soul. For days at a time he remained in that one room pondering its needs.

Once satisfied with the layout as it presented itself to his mind's eye, Whistler fell to work passionately. He took little rest during a period of six months. On his knees or squatting Turkish fashion, he painted the panels of the wainscoting, on a ladder or scaffolding, or sometimes in a hammock, he painted peacocks all over the walls and the ceiling. To reach remote corners he sometimes used a brush fastened to the end of a fishing rod. When the work was done Mr. Leyland marveled at the odd design, the perfect splendor of the coloring, the sumptuous effect, and he named it the Peacock room.

Whistler Takes Characteristic Revenge.

He was delighted, but it appears that there was some deplorable misunderstanding between the merchant prince and the artist as to the amount of compensation the latter was to receive. Probably, taking into consideration Whistler's peppery nature, the fault was not Leyland's. But Whistler felt aggrieved and took a characteristic revenge.

One shutter was still unfinished, and on it he painted two peacocks, one with ruffled plumage, grasping in one claw a pile of gold, to represent Leyland, and the other, calmly indifferent to the other's avarice, to typify himself. Mr. Leyland said nothing and let the designs remain. But the trouble over the room was not only serio-

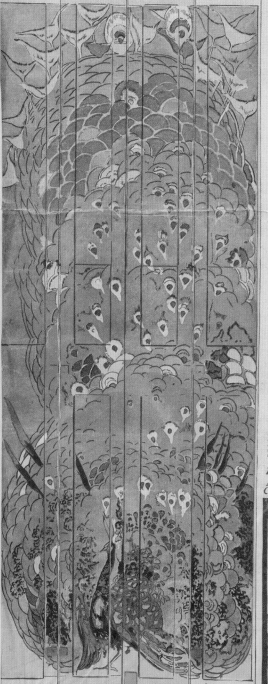

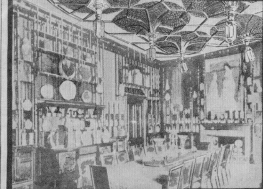

TWO OF THE SHUTTERS FROM THE PEACOCK ROOM AND THE ROOM COMPLETE, AS DESIGNED BY WHISTLER

comic. Jeckyll had taken an immense deal of pride in the apartment. He was a man of extremely sensitive nature, and when he saw all the results of his work gradually obliterated by Whistler's brush he fell into a morbid condition which before long developed into violent insanity. He was found one day painting the floor of his house with gold and threatening to murder Leyland and Whistler. He was removed to an asylum, where he soon afterward died.

Most Striking Interior Decoration.

Critics from London and Paris were invited to view the wonderful creation. They looked around and overhead in astonishment, and declared it to be the most striking piece of interior decoration of the age.

To give the reader a proper conception of the general effect is impossible. The best that can be done is to detach a small bit or two from the panel scheme and try to reproduce the colors faithfully and as accurately as modern presses can print them.

Two of the shutter designs presented herewith give a good idea of the technique, the great detail of the drawings and the extraordinary brilliancy and harmony of hues and tints. As the feathers of the peacock, especially those of the species to be found on the grounds of Warwick castle, present practically every hue of the rainbow, Whistler was not limited in his use of color.

And if an artist ever understood color it was he. In his Peacock room studies he fairly reveled in it. Yet he determinedly guarded himself against the temptation to overpaint. Where a mediocre artist, handling the same design, would have produced something sensational in its flaring splashes, Whistler's object was to obtain a harmonious effect, making the room superbly rich, yet cool and restful.

When Leyland died in 1892, his porcelain collection was dispersed at auction, and his house, including the Peacock Room, was sold. The new owner, Blanche Watney, decided to sell the Peacock Room after she realized it could be taken apart and reassembled. Word of an impending sale soon reached the press, and reporters in both England and the United States speculated that the renowned room would attract an equally famous buyer. One New York newspaper, for instance, reported that art collector and financier J. P. Morgan, the so-called King of Wall Street, had purchased the Peacock Room.

The actual buyer was Charles Lang Freer (1854–1919), who had acquired his own fortune in the business of manufacturing railroad cars. He was also known in the art world as America's foremost collector of the work of Whistler. Even so, Freer, who preferred aesthetic subtlety to gorgeous extravagance, was initially ambivalent about the Peacock Room as a work of art. He did not care for the blue-and-white Kangxi wares, with their "hard and obvious" surfaces, that were once on display in the Peacock Room. He preferred the rougher textures and more subdued glazes of pottery and stoneware. Freer later confessed that he had purchased the room out of a sense of "pleasant duty" to Whistler.

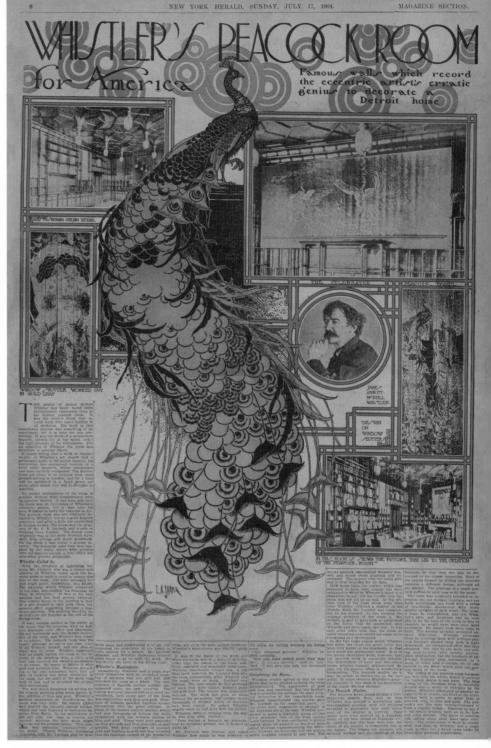

9

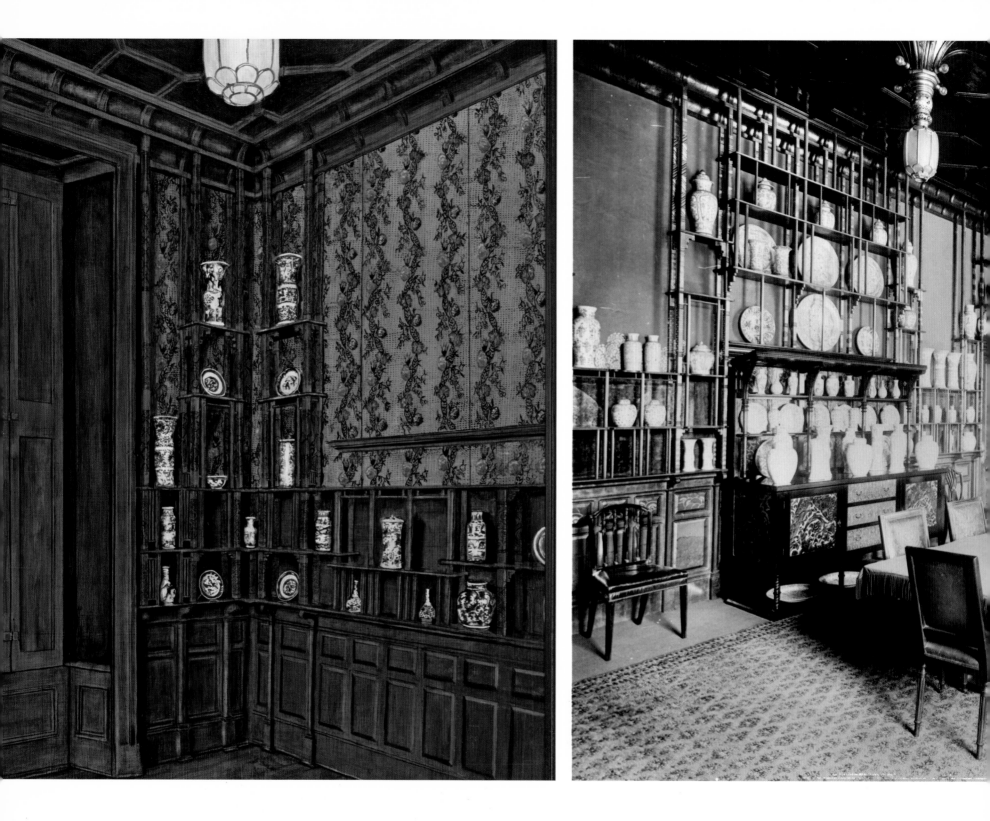

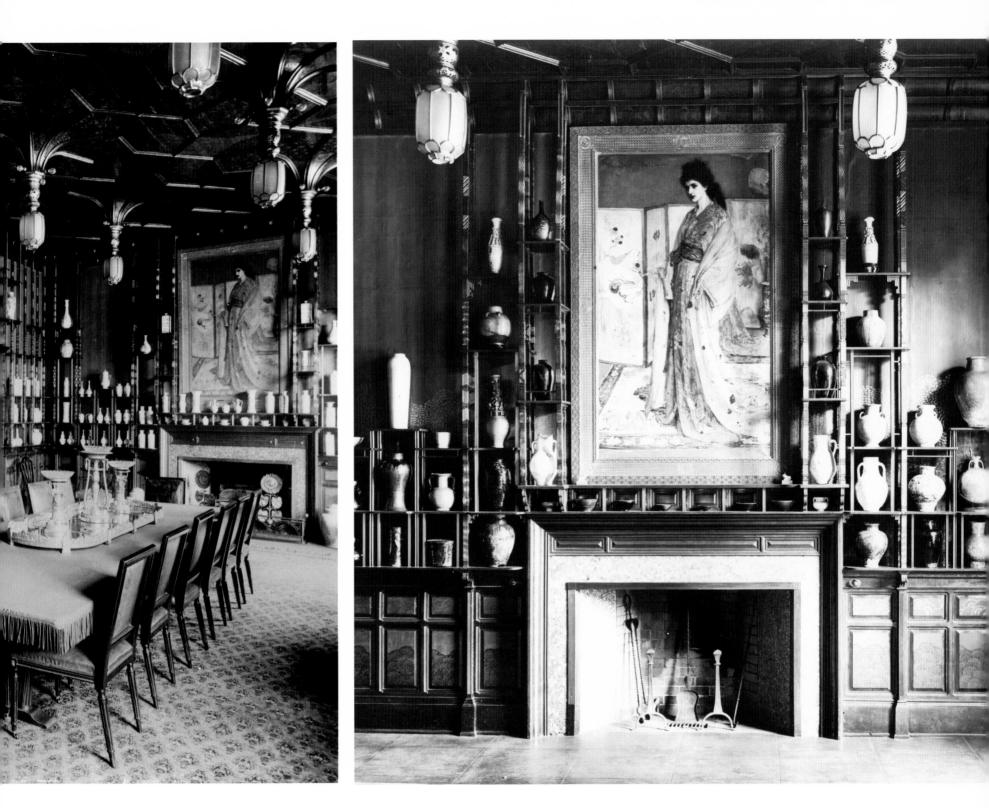

LEFT
Southeast corner of Leyland's dining room at 49 Prince's Gate,
London, as it may have appeared in April 1876

MIDDLE
Northwest view of Peacock Room in London, 1892

RIGHT
North wall of Peacock Room in Detroit, 1908

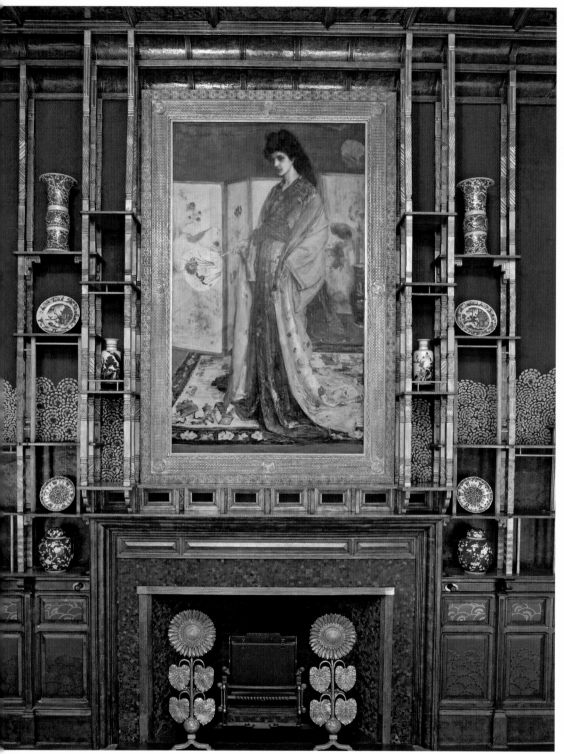

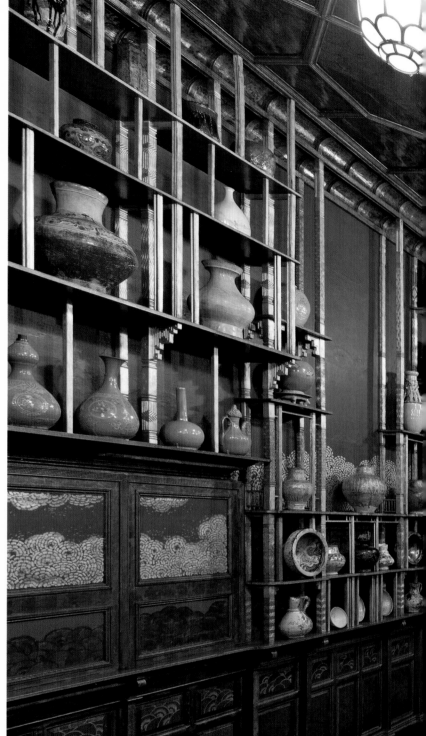

LEFT
North wall as it appeared 1993–2011, with sunflower andirons by Thomas Jeckyll and blue-and-white Kangxi porcelain, to emulate the room's appearance in London from 1877 to 1892

RIGHT
Peacock Room in 2011, installed with Asian ceramics and arranged as they appeared in Freer's home in Detroit in 1908

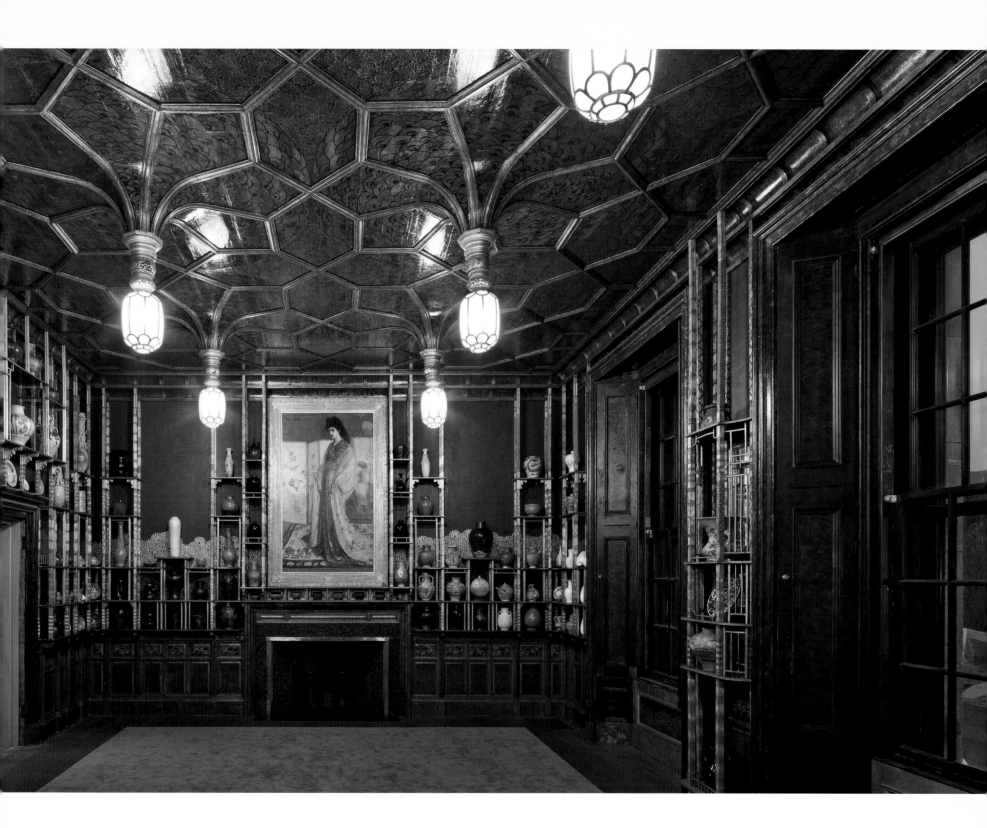

The Peacock Room arrived in the United States in the summer of 1904, after Freer purchased it from an art dealer in London. It was dismantled and shipped across the Atlantic Ocean in twenty-seven crates. After it was delivered to Freer's mansion in Detroit, it was reassembled in a specially built annex, and its shelves were eventually filled with more than 250 ceramics from all over Asia. Although he was interested in each piece individually, Freer was equally concerned with the ceramics' formal relationships to one another and to the Peacock Room as a whole.

TOP
Northwest corner arranged with ceramics from Syria, Iran, China, and Japan, 2011

BOTTOM
South view in Freer's Detroit home, 1908

RIGHT TOP
Freer's home in Detroit, with the Peacock Room annex on the far left, ca. 1910

RIGHT BOTTOM
Charles Lang Freer, owner of the Peacock Room and founder of the Freer Gallery of Art, ca. 1895

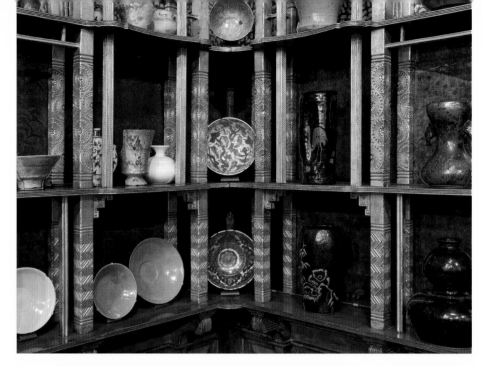

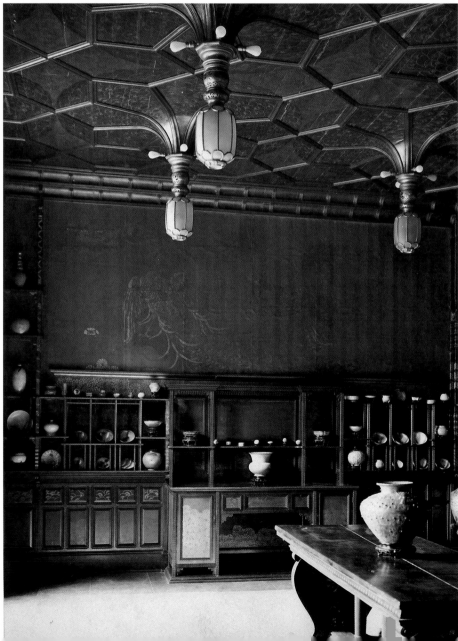

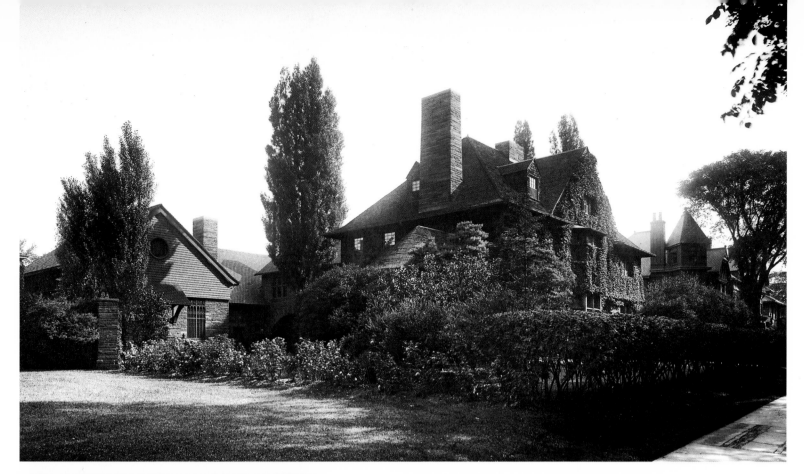

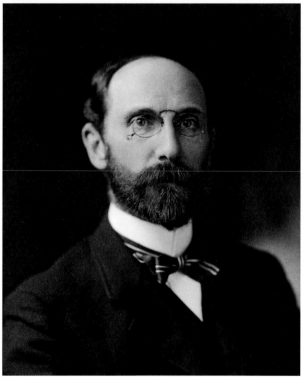

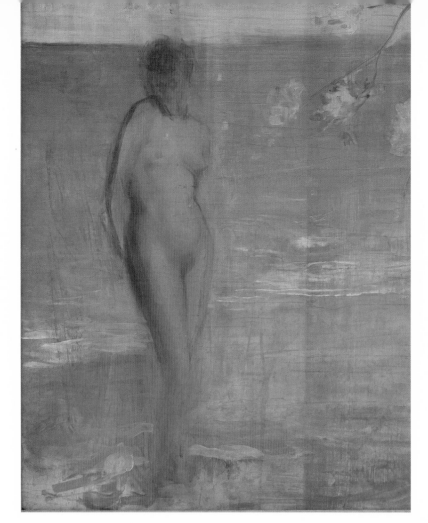

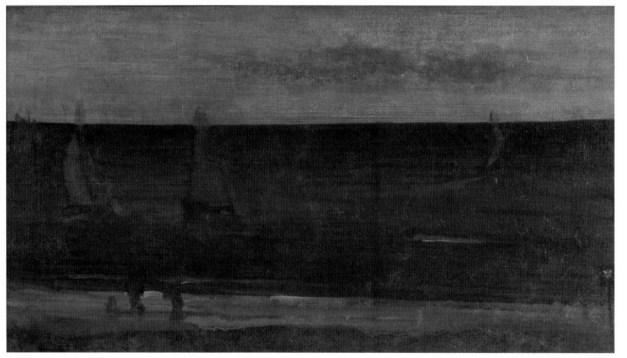

TOP
James McNeill Whistler. *Venus Rising from the Sea*, ca. 1869–70

BOTTOM
James McNeill Whistler, *Nocturne: Blue and Silver—Bognor*, 1871–76

RIGHT
West wall in Detroit, 1908. The door originally led to the butler's pantry

More than a Dining Room

When the Peacock Room came to America, it lost its original function as a dining room, but it gained a new identity as an aesthetic laboratory. In addition to filling the room's shelves with a changing array of ceramics, Freer brought in various objects, such as antique books and ancient Chinese jades and bronzes, that he displayed on a seventeenth-century Italian table in the center of the room. He entertained students, friends, and fellow collectors in the space, where he delighted in making "quiet comparisons" among the decorations of the room, his collections of Asian antiquities, and Whistler's painted Nocturnes. He kept his rare biblical manuscripts in a fireproof safe behind the room's leaded-glass door that originally led to the butler's pantry, and in 1912 he organized a special exhibition of these rare manuscripts in the room. A critic from Washington, D.C., who visited Freer's Detroit home in 1906 admired his "choice specimens of Eastern pottery" and declared the Peacock Room to be "perfectly reset" in its new location.

Freer eventually made the room his own, using it as a staging area for organizing his own splendid collection of Asian ceramics. Comprising examples from countries as diverse as Syria, Iran, Japan, China, and Korea, and ranging in date from prehistoric times to the early twentieth century, the wares feature subtle, often iridescent glazes in shades of turquoise, jade green, and golden brown that harmonized with Freer's collection of American tonalist paintings by Thomas Dewing, Dwight Tryon, and Whistler.

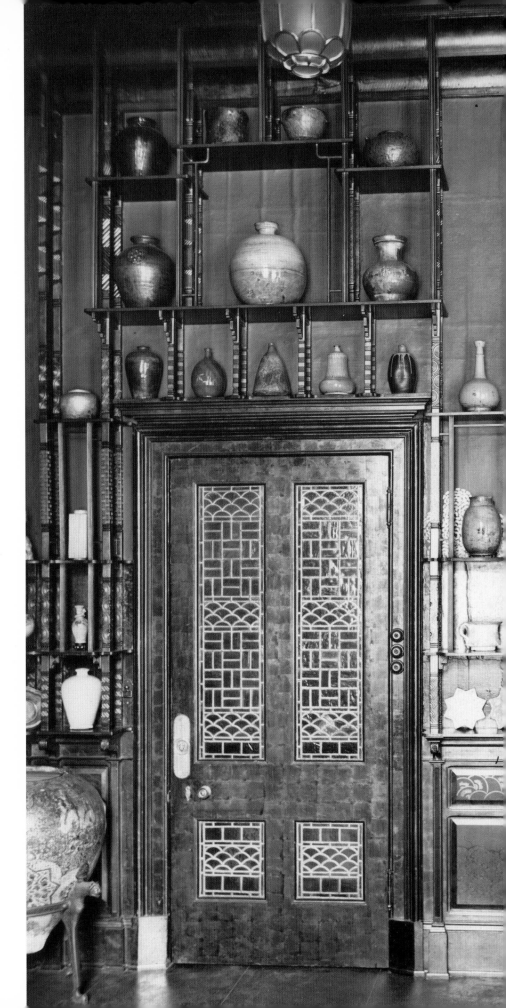

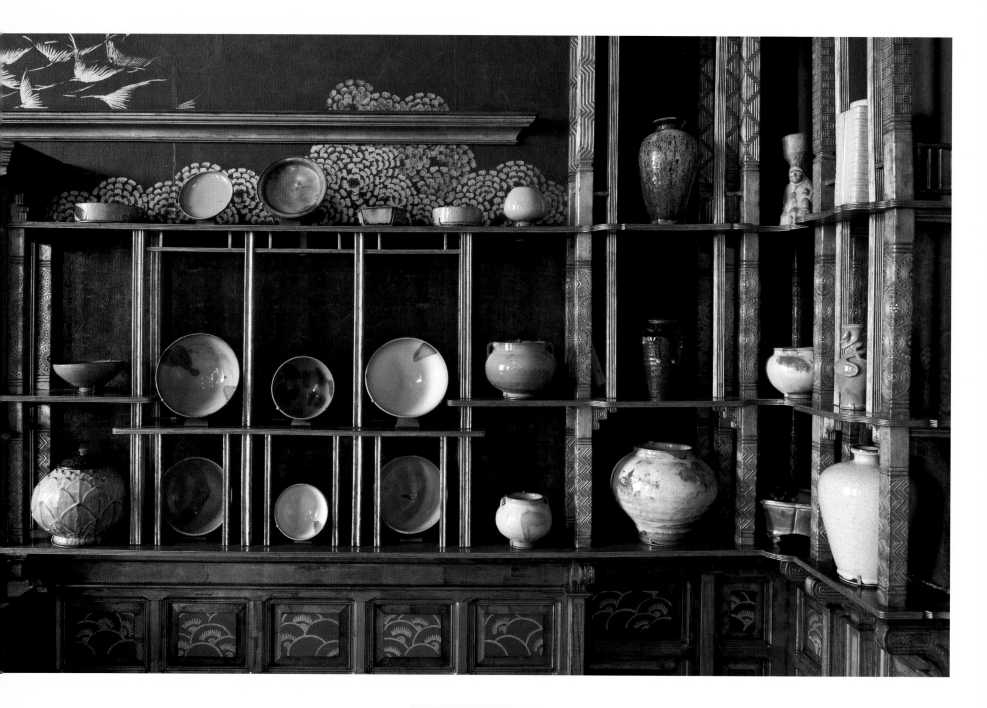

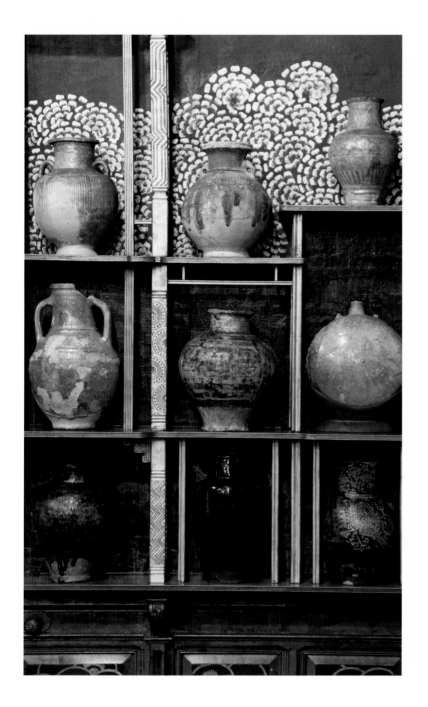

Well pleased with the unexpected but harmonious aesthetic relationships he orchestrated, Freer commissioned George R. Swain, a photographer in Detroit, to document the room in 1908. Those images, now part of the Charles Lang Freer Papers, formed the basis of the 2011 reinstallation, which, like its original incarnation, underscores Freer's belief that "all works of art go together, whatever their period." That faith in cross-cultural aesthetic harmonies, rehearsed when the Peacock Room came to America, achieved its ultimate expression in the Freer Gallery of Art, which opened to the public in 1923 as the Smithsonian Institution's first museum dedicated to the fine arts. Here, Whistler's magnificent interior decoration remains on permanent display, fittingly located between galleries of Chinese and American art.

LEFT
South wall installed with Jun and Jun-style
ware from China

RIGHT
North wall installed with Raqqa ware
from Syria

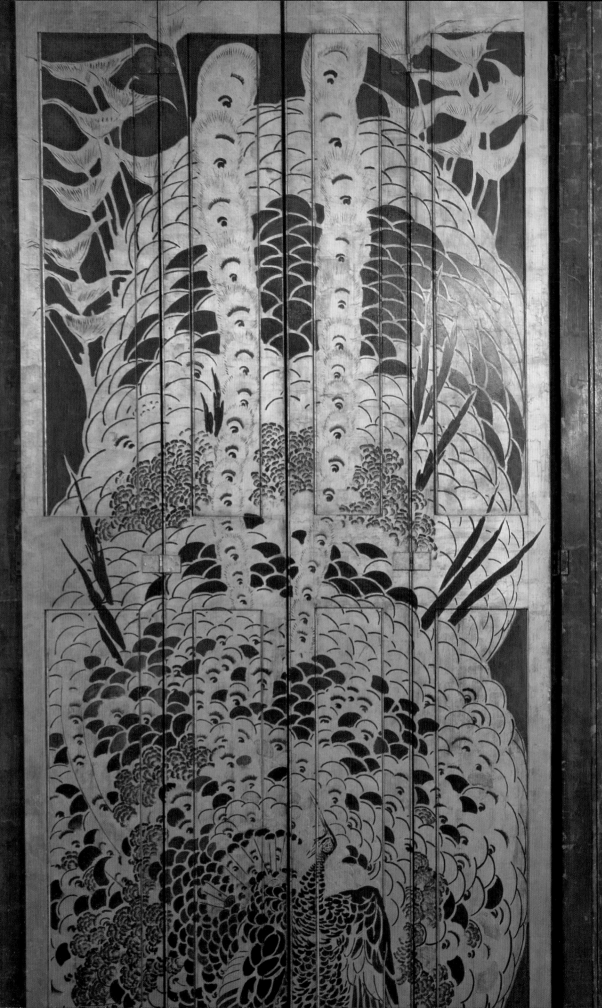
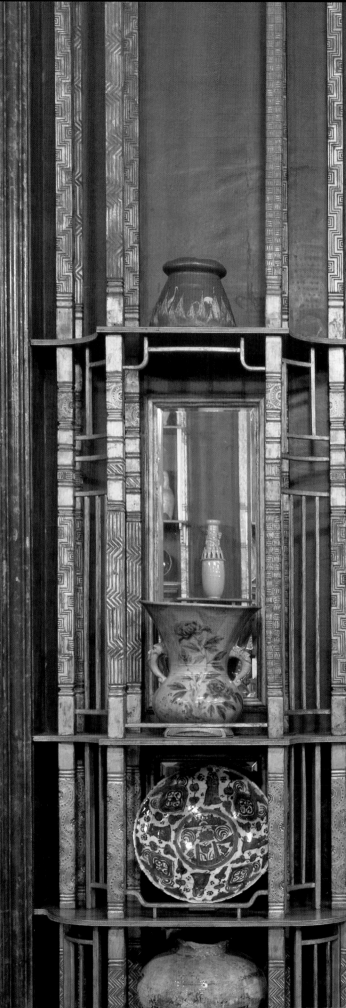

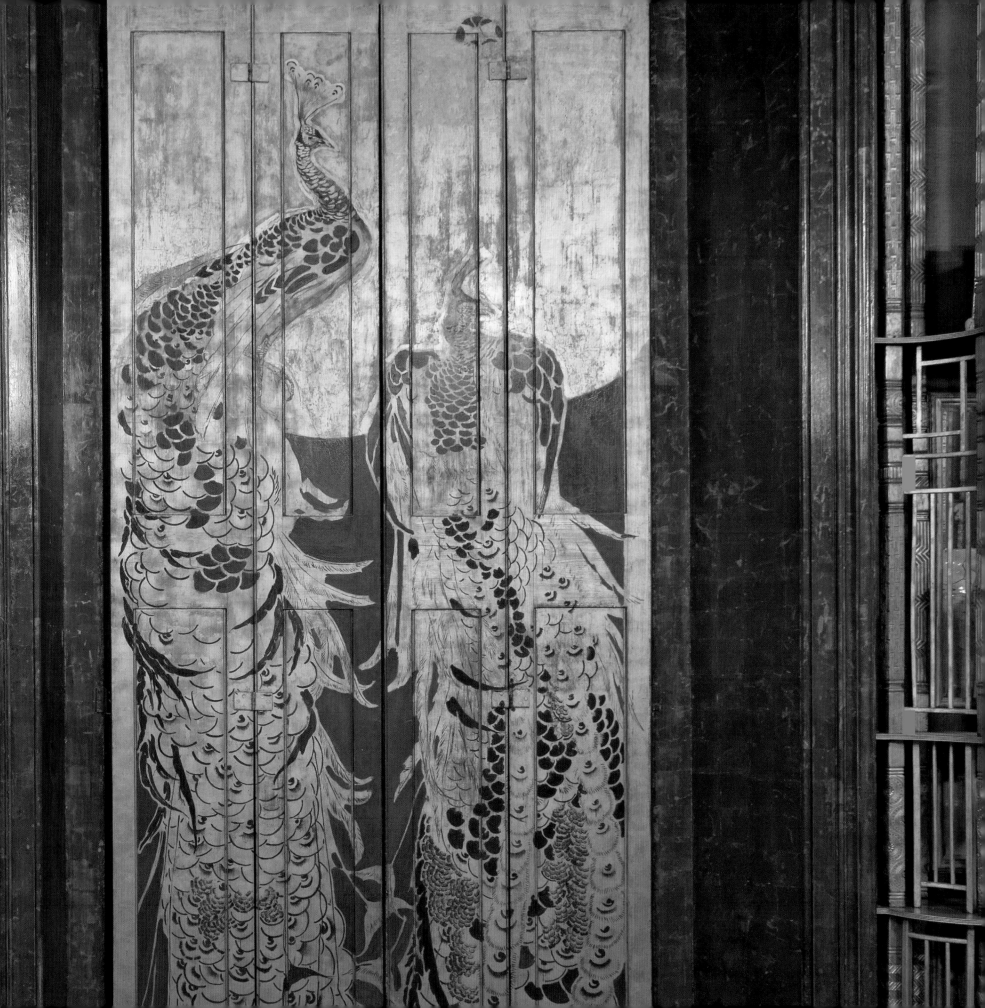

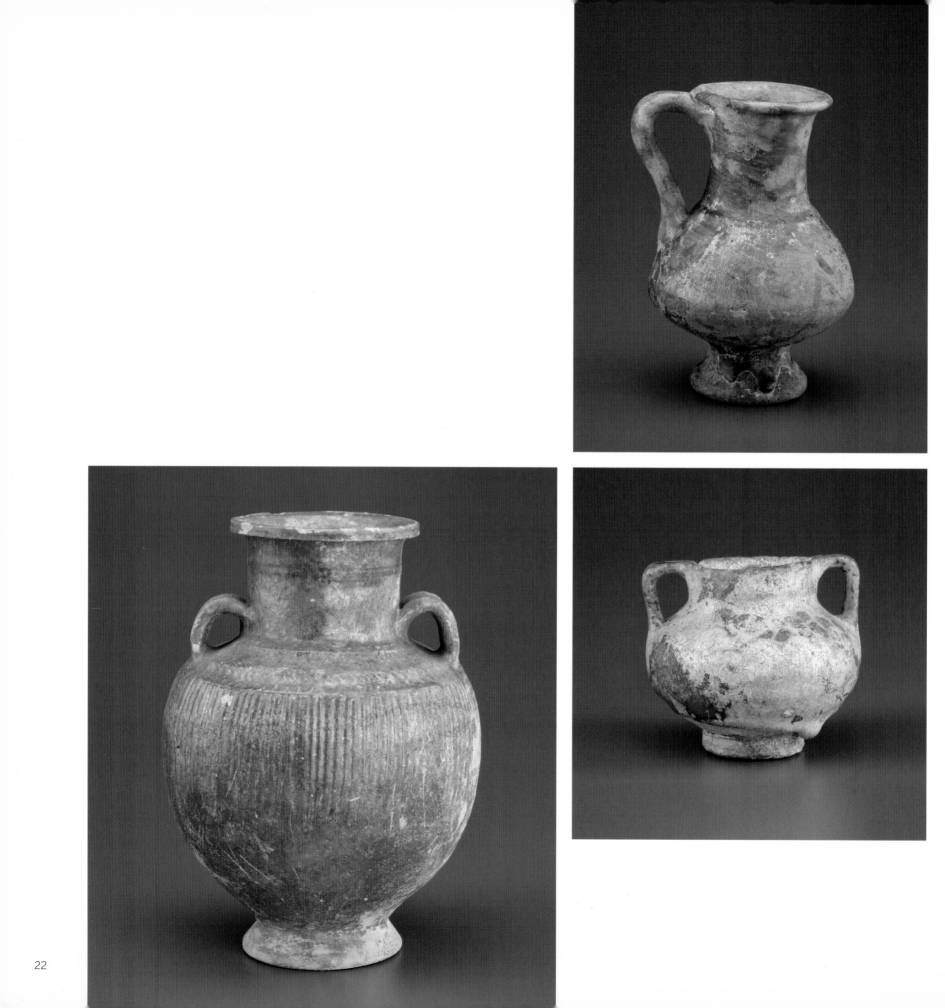

Choice Specimens of Eastern Pottery

Raqqa Ware: Beautiful and Iridescent

Freer first became interested in Syrian, Mesopotamian, and Persian ceramics in the late 1890s. Although he purchased some of his pieces during his travels in Egypt and the Near East, most of his pottery from the region came through two Paris-based art dealers: Siegfried Bing (1838–1905) and Dikran Kelekian (1868–1951). Bing initially played a key role in introducing Japanese art to collectors in Europe and the United States, but around 1900 he turned to the arts of the Islamic world, where recent excavations had unearthed centuries-old ceramics. Kelekian started selling antique Islamic ceramics in the 1880s and 1890s. In addition to operating art galleries in Paris and New York, he oversaw the Persian pavilions at several international expositions. Kelekian's stock attracted the attention of several notable American collectors, such as Freer, Henry Walters, Isabella Stewart Gardner, and Louisine and Henry O. Havemeyer.

In his 1909 history of Near Eastern ceramics, *The Potteries of Persia*, Kelekian described Raqqa pottery from Mesopotamia—ceramics with a gritty white body and thick alkaline glazes—as "beautiful in color and heavily encrusted with iridescence." He noted that "discriminating" collectors "have grown to love it with a deep and abiding affection quite within the scope of their own emotional experiences."

Kelekian's idea of an emotional connection between the collector and the ceramics he acquired certainly resonated with Freer, who was an early enthusiast for Raqqa pottery, which he believed complemented his other artistic holdings. He began collecting ceramics in 1892, when he purchased a Japanese Satsuma-ware bottle (see page 33), whose decoration reminded him of subtle landscapes by Whistler. From 1897 to 1902 he collected large quantities of celadon and other glazed stonewares from Japan, China, and Korea by purchasing them from dealers in Boston, New York, and Paris. During this period he bought his first piece of Raqqa, a type of ceramic named for the site in north-central Syria

PREVIOUS PAGES
Detail of east wall

TOP
Pitcher, Syria, Raqqa, 12th–13th century

BOTTOM LEFT
Jar, Mesopotamia, Parthian period, 1st–3rd century

BOTTOM RIGHT
Jar with two handles, Syria, Raqqa, 12th–13th century

where it was thought to have originated. The turquoise- and green-glazed vessels appealed to Freer because of their chromatic correspondences with his East Asian ceramics, and over the next fifteen years he amassed a significant collection. In Detroit these Raqqa wares were prominently featured throughout the Peacock Room, most notably on what is now the north wall, arranged around Whistler's painting *La Princesse du pays de la porcelaine*, and in the eye-level shelves on the west wall between the two doors.

In 1908 Freer embarked on a "quest to the Holy Land." He traveled to Egypt, Palestine, Lebanon, and Syria, hoping to enhance his understanding of his Egyptian and Near Eastern acquisitions. "I have invested pretty heavily in this line," he explained, "and I consider it necessary to learn what I can." Despite Freer's efforts, accurate information about Raqqa pottery did not become available until after World War II, when new excavations at Raqqa and other Syrian sites allowed for a revised understanding of earlier finds. Freer believed many of his pieces, heavily abraded and encrusted with decay, were much older than they are now known to be. (Most of them date to the eleventh through the thirteenth century.) In any case, Freer was attracted to the coarse, opalescent surface textures—the result of chemical decomposition of the glaze from prolonged burial in soil—and some of his favorite pieces were those on which the glaze had almost entirely eroded. The soft, rough appearance reminded him of the coarsely woven canvases and textured papers that American artists used in the works he collected.

The 2011 reinstallation of the Peacock Room marked the first time that a large quantity of Freer's Raqqa wares has been displayed since the museum opened in 1923.

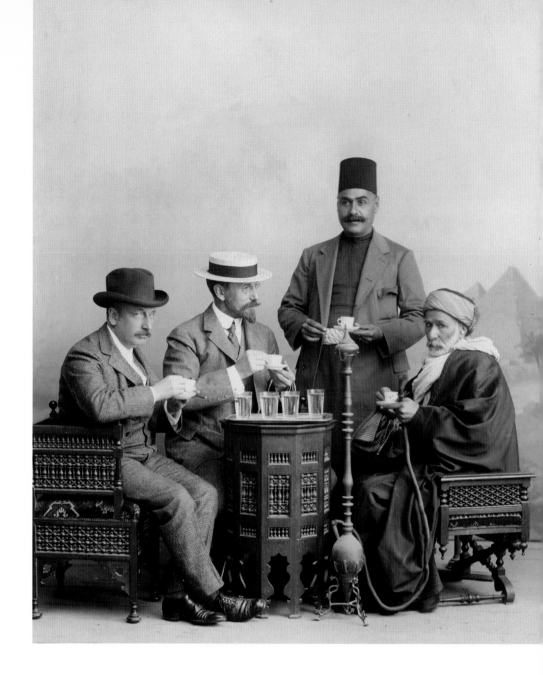

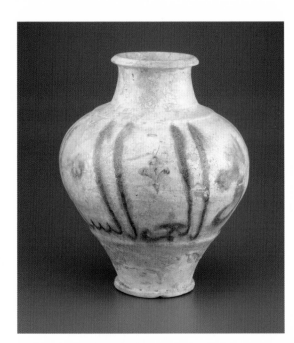

LEFT
Charles Lang Freer (second from left) in Egypt,
with Dr. Frederick Mann (far left), Ibrahim Ali,
and Ali Arabi, 1907

TOP
Jar, Syria, Raqqa, 12th–13th century

BOTTOM
West wall installed with ceramics from
Syria and Iran

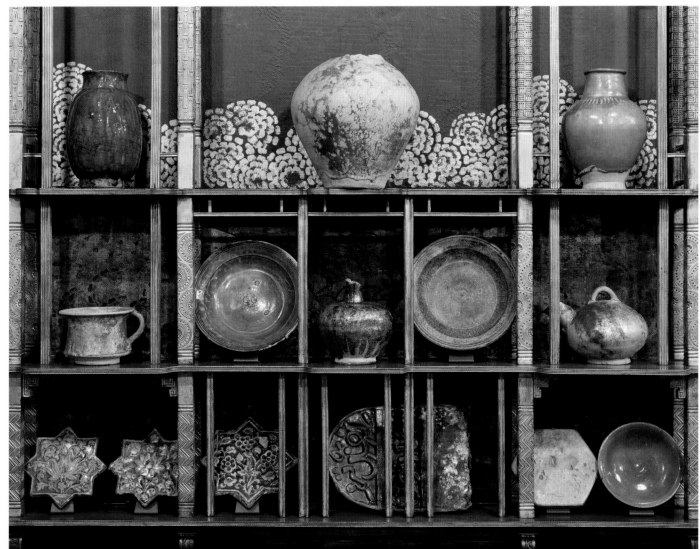

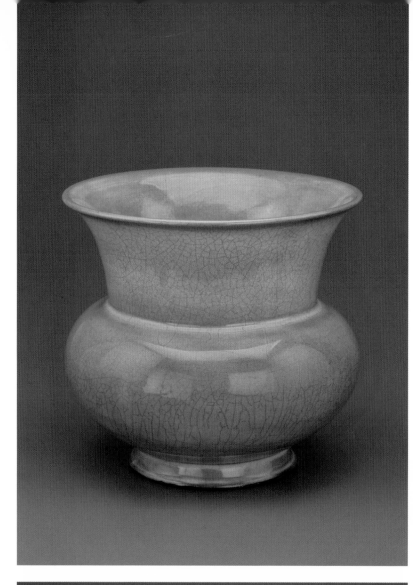

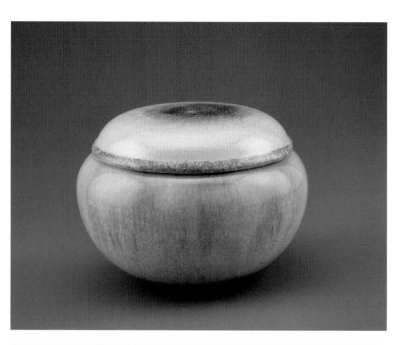

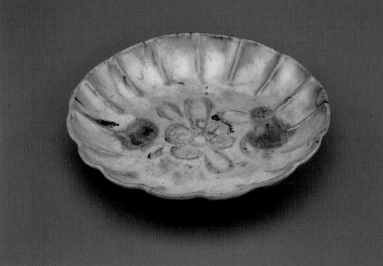

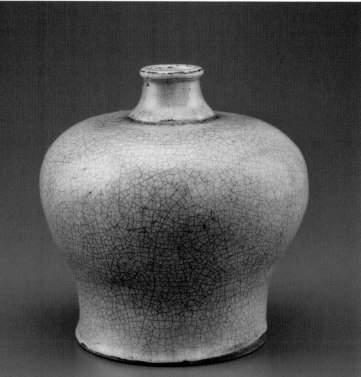

Jun Ware: Harmonies in Blue

Traditionally considered one of the five "great wares" of Chinese ceramics, Jun ware was produced at several kilns in Henan province from the Song dynasty (960–1279) through the fifteenth century. Freer purchased many of these pots, including the splendid planter that occupies the center of the sideboard (see page 29), during his 1907 trip to China. Other pieces of Jun ware were acquired at auction or from art galleries in New York and Boston. The small lidded bowl and the bottle on the far left of the sideboard, for instance, came from the 1898 sale of the Chinese porcelain collection of journalist Charles Dana. The bottle was described in the auction catalogue as "invested with a rich yellow and pale *claire de lune* glaze, permeated by a double crackle in violet and brown." Freer circled the entry and noted, "Most perfect." The reference to *claire de lune*, a luminous blue glaze associated with Chinese ceramics, suggests Freer and his contemporaries regarded this bottle to be an example of Jun ware and dated it, therefore, to the twelfth century. More recent scholarship, however, has revealed that this is a much later specimen, a "Jun-style" piece produced during the Qing dynasty, sometime between the seventeenth and the nineteenth century.

Freer also acquired quite a few Jun-style pots from the New York gallery of Yamanaka and Company, which dealt in both Japanese and Chinese art. Many of these pieces, such as the decorative dish he purchased in 1905, were thought to be older than they are now known to be. This was largely due to a misunderstanding of how Chinese ceramics had developed through history. Most Western collectors in Freer's day favored highly decorated porcelains, and they assumed the monochromatic, less delicate pots must be older and from an earlier, less sophisticated period of production. Although Freer was interested in the historical origins of his ceramics, he was more attracted to their purely formal qualities of shape and color. This was certainly part of the allure of those pieces that he identified as Jun ware. The distinctive blue colors of the glaze, ranging from greenish blue to violet, result from a chemical reaction that occurs during the firing and cooling process. Variations in tone happen in areas with thicker glaze, creating a chromatic complexity that Freer appreciated. He displayed more than forty pieces of Jun ware and other similarly blue-glazed ceramics in the Peacock Room, which he often referred to as "the Blue Room." Massed just beneath Whistler's allegorical mural of two battling peacocks, these pots created a ceramic "harmony in blue" that resonated with Whistler's interior decoration.

TOP LEFT
Planter, China, Northern Song dynasty, 11th–early 12th century

BOTTOM LEFT
Dish with molded decoration, China, Ming or Qing dynasty, 17th century

TOP RIGHT
Vessel in shape of a lidded alms bowl, China, Qing dynasty, 18th–19th century

BOTTOM RIGHT
Bottle, China, Qing dynasty, 17th–19th century

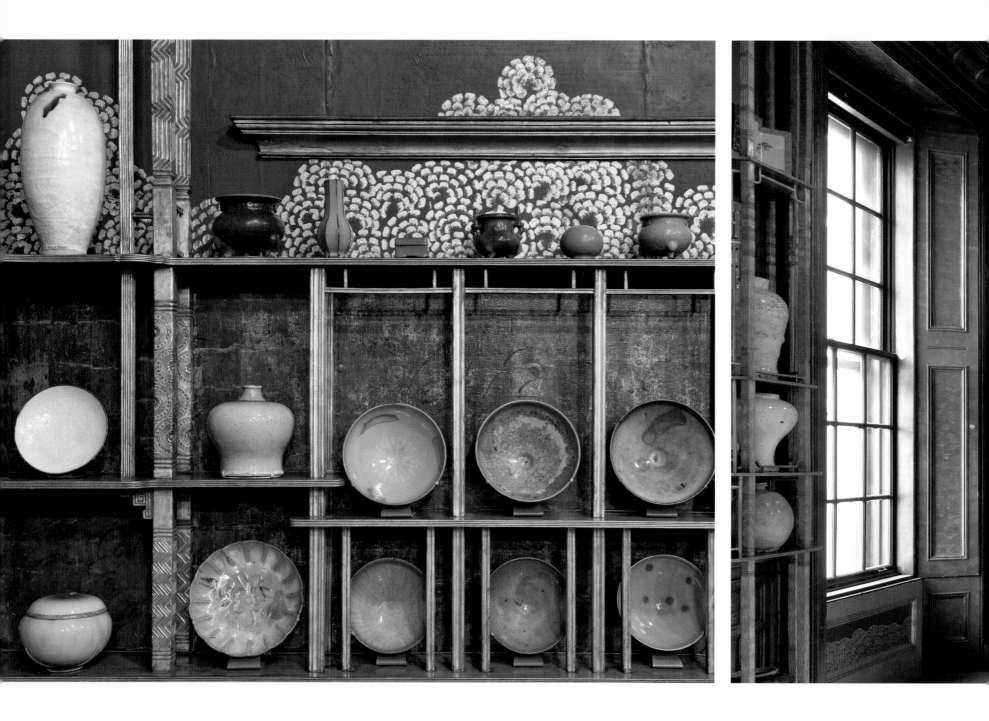

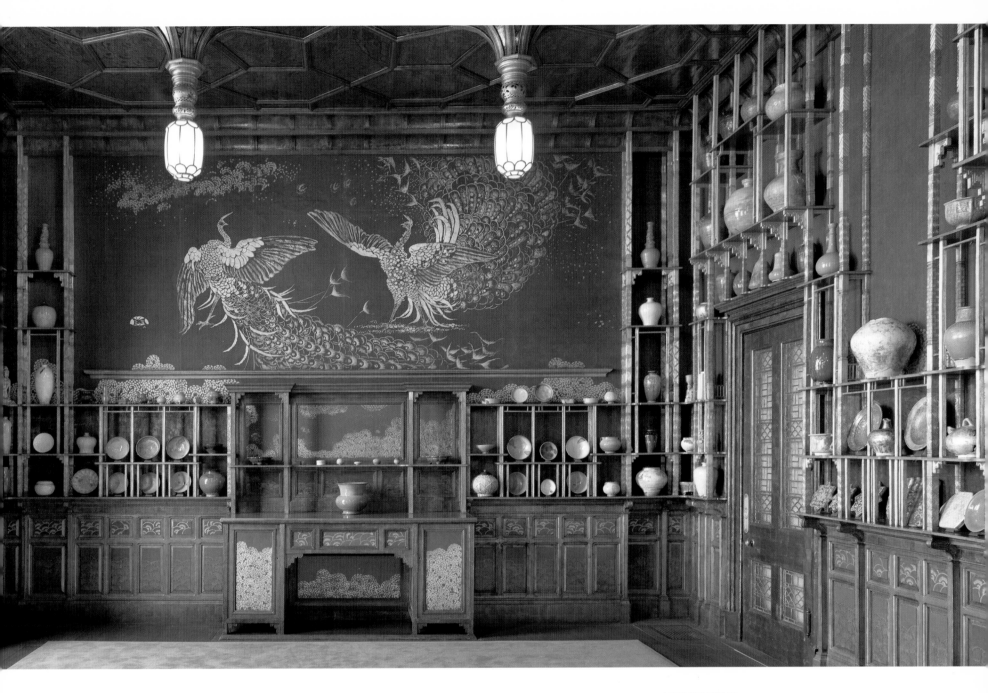

Korean Celadons, Chinese Funeral Jars, and "Whistlerian Landscapes" from Japan

When Freer organized his ceramics in the Peacock Room in Detroit, he displayed on the shelves between the two doors an array of celadons from Korea and funeral wares from China's Han dynasty (206 BCE—220 CE). He also presented there a pair of eighteenth-century sake bottles from Japan's Edo period, one of which was the very first Asian ceramic he had purchased more than fifteen years earlier in 1892.

Freer began to acquire Korean ceramics in the late 1890s from the New York gallery of Yamanaka and Company. He obtained an additional eighty Korean pots from the sale of the Horace Allen collection in 1907. Allen, a Presbyterian medical missionary, first traveled to Korea in 1884 and went on to assemble a remarkable collection of ceramics from the tombs of Korean nobility. Those shown in the Peacock Room were mostly celadons, which derive their characteristic color from traces of iron in the glaze and are fired in a high-temperature reducing atmosphere, created by over-stoking the kiln and lowering oxygen levels. Chinese potters first developed this technique

before it was used in Korea in the tenth century. Freer filled the six bottom shelves in the center of the west wall of the Peacock Room (opposite the gilded shutters) with an array of celadon ewers and bottles, whose grayish green glaze, some with crackled surfaces and areas of brown, harmonized with the green, slightly iridescent Chinese funeral jars just above them. Dating to the Han dynasty, these jars originally would have contained offerings of food for the deceased in the afterlife. Freer was probably more interested in their textured, silvery

LEFT
West wall installed with ceramics from
Japan, China, and Korea, 2011

RIGHT
Same wall as it appeared in Freer's
Detroit home, 1908

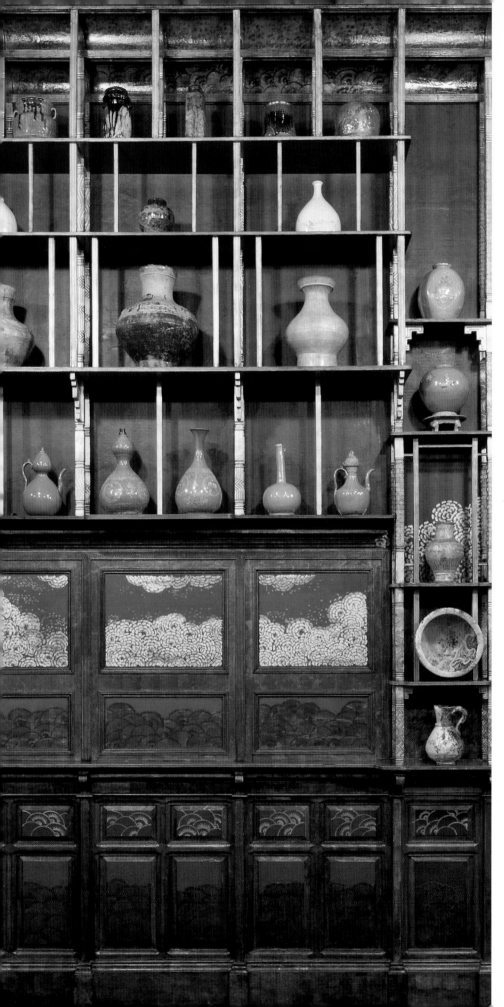

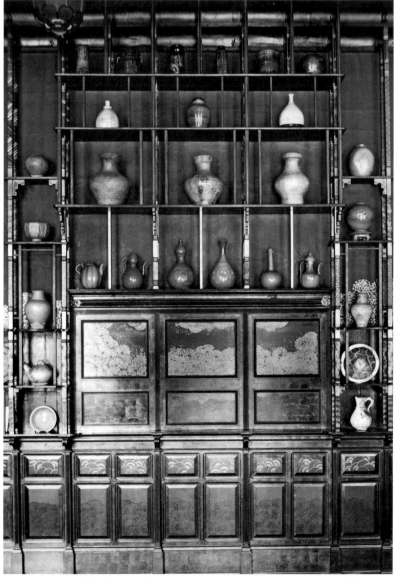

green surfaces than in their cultural significance. Around the same time he purchased these jars and the Korean celadons, he was also acquiring medieval Near Eastern Raqqa ceramics and contemporary art pottery from Detroit's Pewabic workshop, all of which feature similar mottled surfaces and shimmering tonalities. These qualities, for Freer, harmonized with the tonalism of his American paintings collection.

The aesthetic relationship between East and West was even more explicitly conveyed—at least for Freer—by the pair of Satsuma sake bottles that he placed just above the Han funeral jars. The faceted hexagonal vessel bears scenes of fishermen along a river (top left). In his inventory notes, Freer described this delicate image as "a Whistlerian landscape." Freer appreciated the parallels between this jar's refined decoration and the Japanese and American paintings he collected. In 1905 he acquired the second sake flask (bottom right), which was decorated so similarly to his first ceramic piece that he considered it to be "by the same workman." Freer believed him to be Kano Tangen, an artist from Satsuma province who trained in Edo in the workshop of the famous Kano Tan'yu (1602–1674).

TOP LEFT
Bottle, Japan, Hiyamizu kiln, Satsuma ware, Edo period, 18th century

BOTTOM LEFT
Tomb jar, China, Eastern Han dynasty, early 1st–3rd century

TOP RIGHT
Ewer, Korea, Jeolla-do province, Gangjin or Buan kilns, Goreyo period, 12th century

BOTTOM RIGHT
Sake bottle, Japan, Kiyamizu kiln, Satsuma ware, Edo period, 18th century

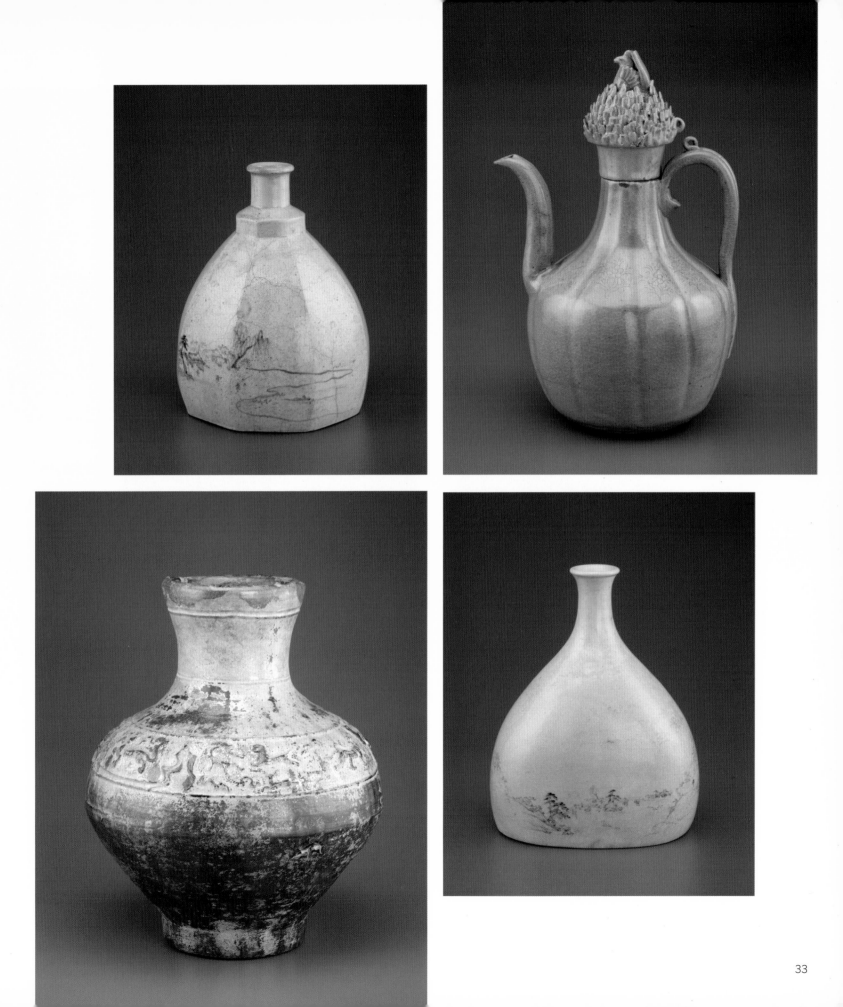

"All Works of Art Go Together"

By placing such varied pottery in close proximity—to one another and to the work of Whistler in the Peacock Room in Detroit—Freer suggested a mode of aesthetic appreciation that he had explained some years earlier in a letter to collector John Gellatly. "Throughout the entire range of Whistler's art, one feels the exercise of spiritual influences similar to those of the masters of Chinese and Japanese [art]. Of course," Freer concluded, "Mr. Whistler does unite the art of the Occident with that of the Orient."

A pair of photographs by Alvin Langdon Coburn, who created the first color images of the Freer collection in 1909, presents Freer's aesthetic philosophy in visual terms. In the first (bottom right), Freer compares the iridescent glazes of a Raqqa pot to the subtle tonalities of a Whistler nude (see also page 16). In another photograph (top right), he gazes at the viewer as he poses beside two ancient Egyptian statuettes and a tiny Whistler pastel of a draped figure inspired by ancient Greek Tanagra figurines. These images, with their multiple cultural references, not only function as a form of autobiography, but they also demonstrate the kind of looking that Freer hoped to encourage at his art museum. In the context of his aesthetic philosophy, Korean celadons could be understood both in relationship to their Chinese precursors and alongside Jun ware, Raqqa pottery, Japanese tea wares, and paintings by Whistler. As a contemporary critic noted, "It was Mr. Freer's idea that the art world revolved around a common center of great elemental inspiration. Thus one could discover the relation of one art to another and read Whistler with the same language that interpreted the Oriental."

LEFT
Southeast corner installed with ceramics from China

TOP RIGHT
Freer posing with two Egyptian statuettes and Whistler's *Resting*

BOTTOM RIGHT
Freer comparing Whistler's *Venus Rising from the Sea* with a twelfth-century Syrian pot
Photographs by Alvin Langdon Coburn, 1909

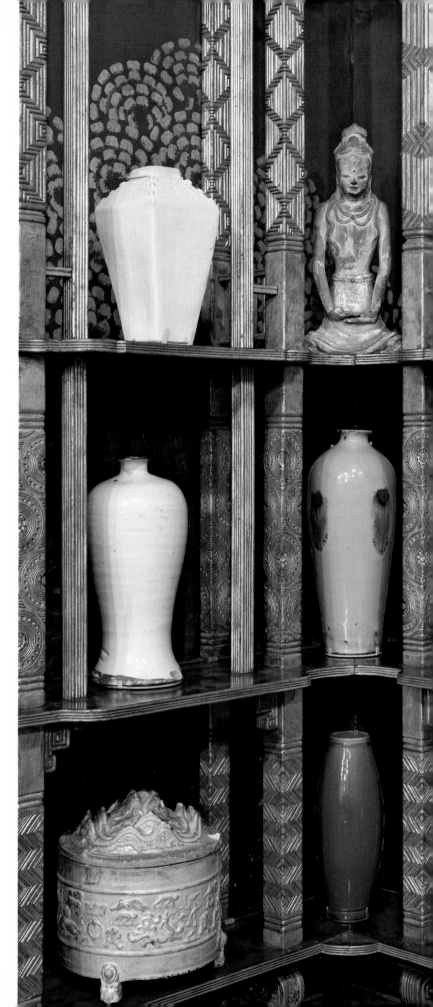

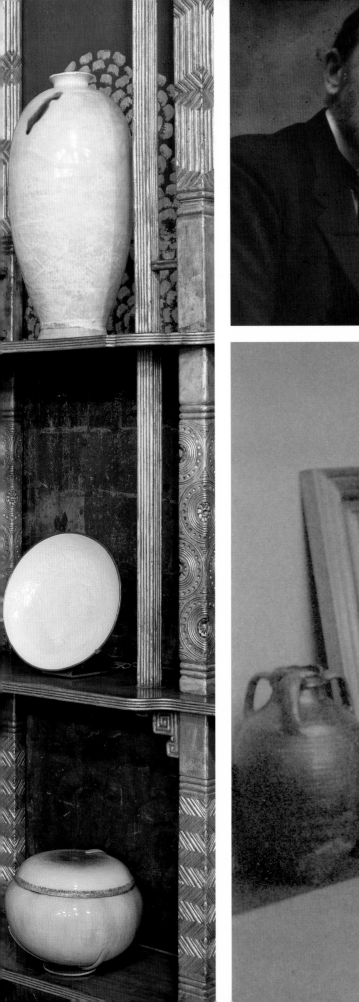

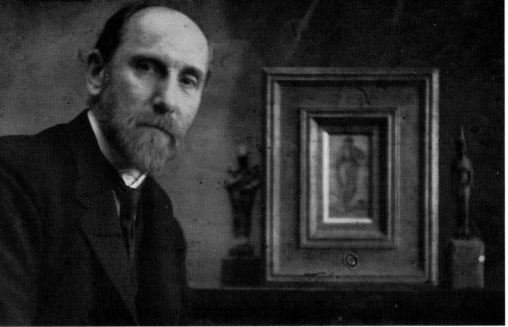

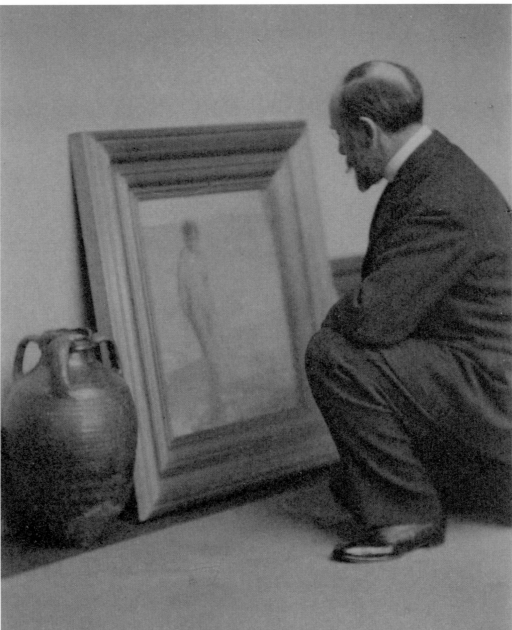

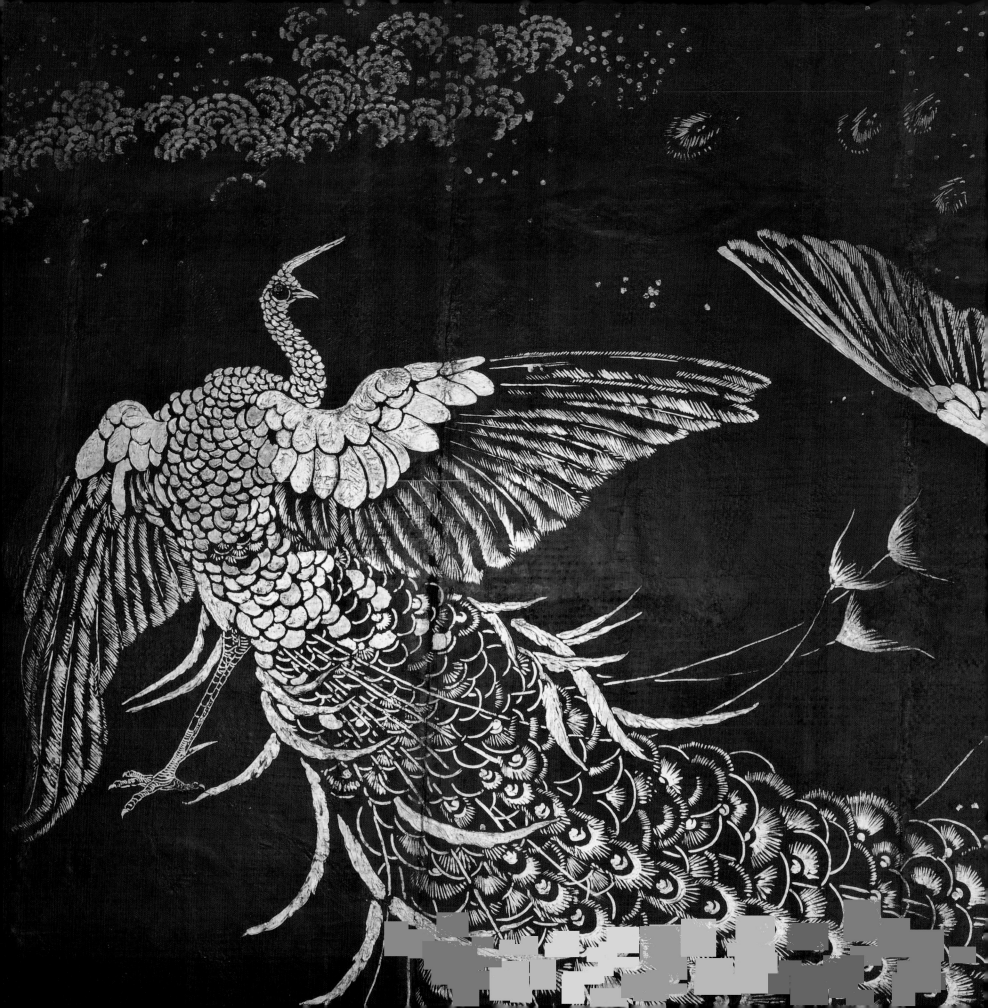

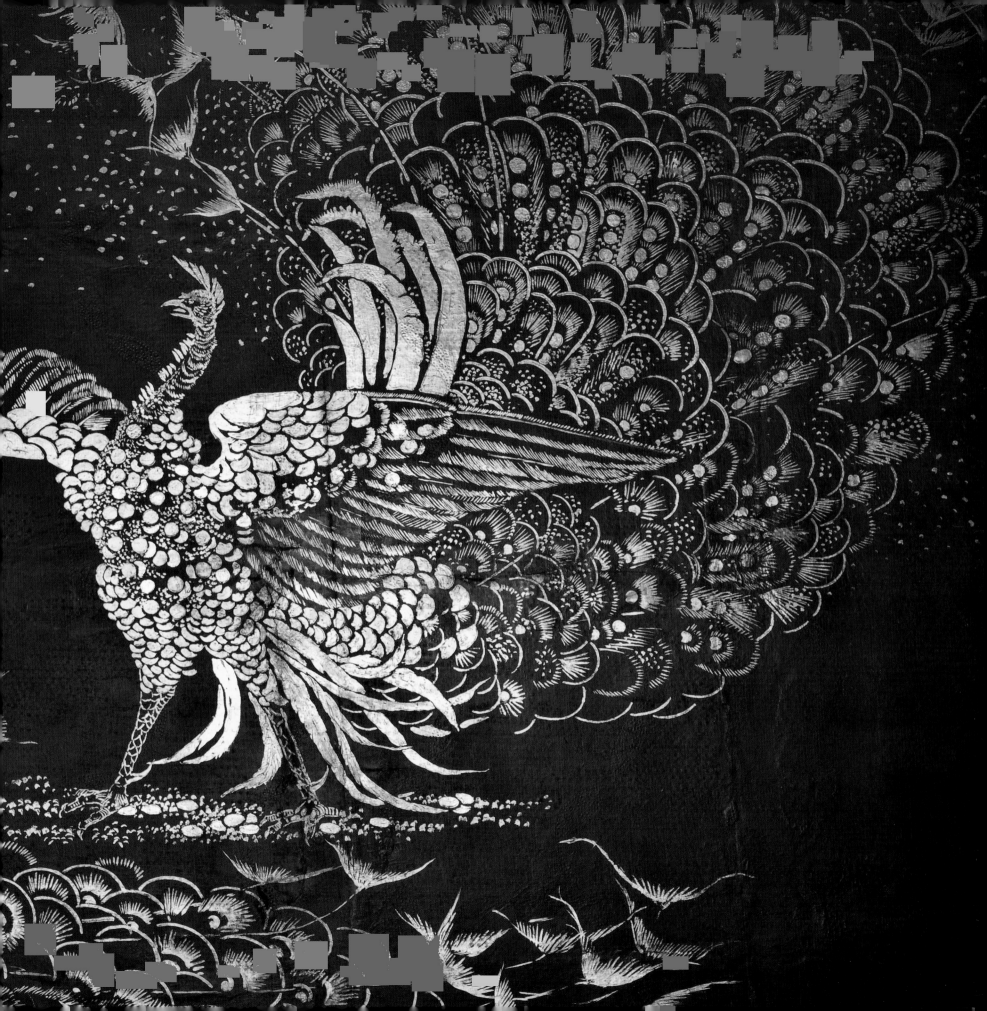

Stories of the Beautiful

Charles Lang Freer derived his notion of a timeless, universally accessible history of art from James McNeill Whistler, an expatriate American painter and print-maker living in London. "The story of the beautiful," Whistler had declared in 1885, "is already complete—hewn in the marbles of the Parthenon—and broidered, with the birds, upon the fan of Hokusai...." Today, Whistler's idea that art transcends the particularities of time, place, and culture is no longer readily accepted. Far from being "already complete," stories of the beautiful are continuously written and rewritten. The Peacock Room exemplifies the dynamic nature of cultural and personal definitions of beauty. Rather than remaining static over the past 130 years, it has undergone a variety of incarnations to suit the changing tastes of its owners and audiences.

Freer, an industrialist who lived during the Gilded Age at a time of staggering growth in wealth and expansion in the United States, enjoyed the not-so-universal privileges of prosperity, mobility, and cultural ascendency. He added a new chapter to the story of the Peacock Room when he brought it to America, one that was relevant to him, to his interest in collecting Asian antiquities and contemporary American painting, and to his particular moment in history. Like Whistler, Freer may have envisioned a cosmopolitan aesthetic narrative of cross-cultural beauty that was "already complete," but the museum he founded remains an open book, its artistic legacy a rich mine of material for creating subsequent chapters on the subject of East-West interchange.

PREVIOUS PAGES
South wall showing the fighting peacocks mural that Whistler called *Art and Money; or, the Story of the Room*

TOP LEFT
James McNeill Whistler, 1885. Photogravure attributed to Mortimer Menpes

BOTTOM LEFT
Whistler's signature and butterfly cipher, ca. 1883

RIGHT
Peacock in the courtyard of the Freer Gallery of Art, 1923. Photograph by Arthur Genthe

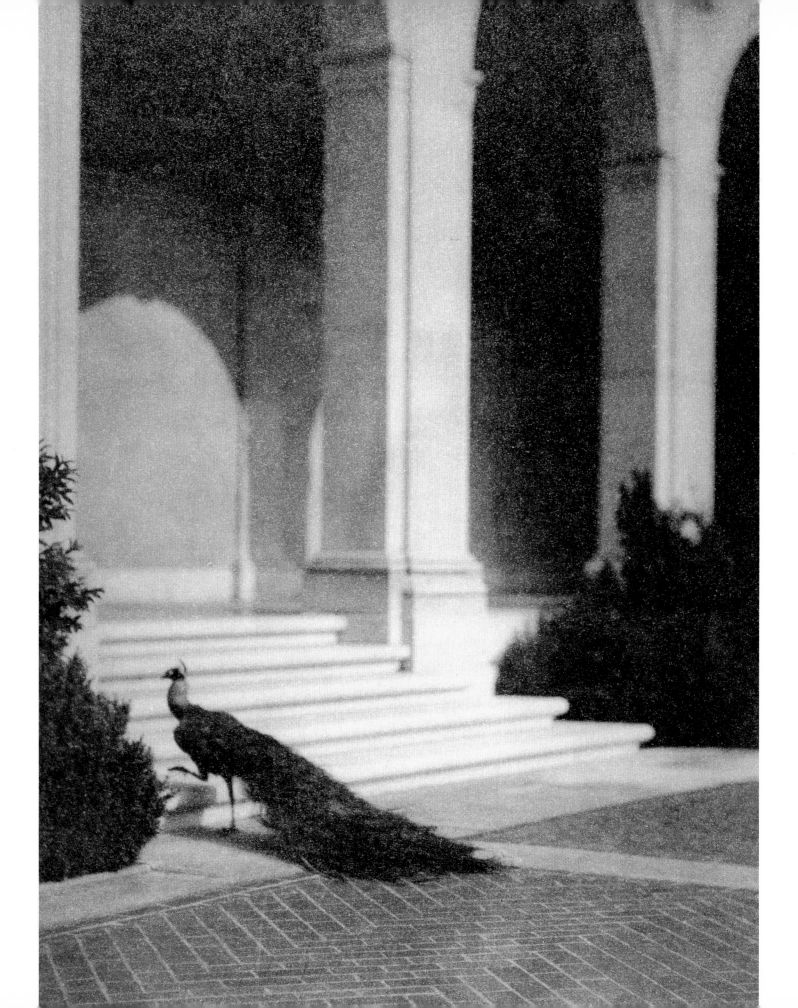

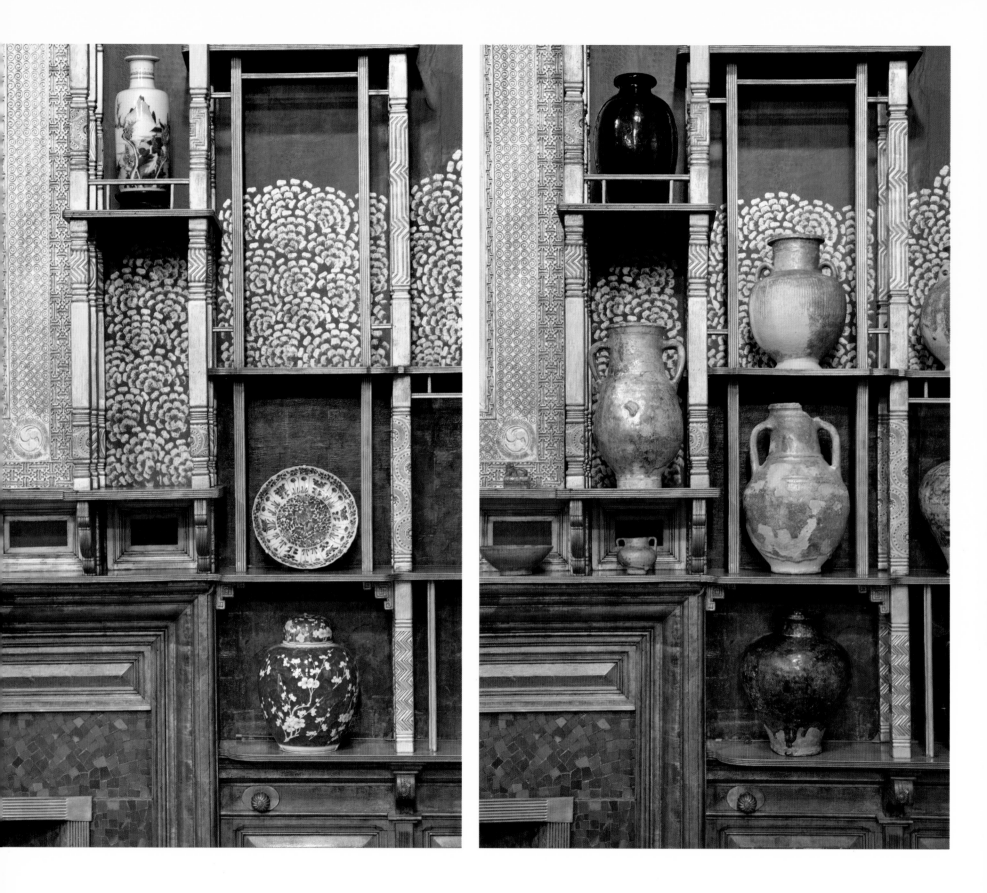

Artistic Room or Work of Art?

The Peacock Room is both an exhibition space and a singular work of art. On the museum's floor plan, it is a gallery. As a work of art it has the title *Harmony in Blue and Gold: The Peacock Room* and the accession number F1904.61, which means it was the sixty-first item to enter Freer's collection in 1904. For Whistler, who decorated the room and regarded it as a single, unified entity, the distinction between exhibition space and work of art was never in question.

When Freer purchased the room, its gorgeous harmonies of blue and gold had already faded, the result of decades of exposure to London smog, gaslight, and cigar smoke. After the Peacock Room came to Washington, it underwent several conservation efforts over the course of the twentieth century (see page 48). The most important of these was the most recent: A major conservation project carried out from 1989 to 1992 restored the room to its original brilliance and revealed the coherence of Whistler's design for the first time in decades. At that time a campaign was launched to acquire blue-and-white Chinese porcelain in an effort to emulate the appearance of the room as it had looked in London during Whistler's day. (For most of the museum's history, the Peacock Room had housed a changing array of Asian and American ceramics, though never in great numbers.) Over the past twenty years, the Peacock Room has been regarded, more or less, as an inviolable work of art. That approach has both advantages (respecting Whistler's artistic intentions) and disadvantages (rendering the room "iconic" and therefore static). In his own time Freer was uncertain about the status of the room, despite his reverence toward Whistler, and he ultimately used it to justify his own approach to collecting and displaying works of art. *The Peacock Room Comes to America* once again raises the question of the room's proper identity.

Is it better to present the Peacock Room as an exhibition space, in which Whistler's decorations are juxtaposed with diverse works from Freer's collection? Or should the room be preserved, to borrow Whistler's phrase, as "the heirloom of the artist"?

LEFT
North wall installed with blue-and-white Kangxi porcelain, as it appeared 1993 to 2011

RIGHT
Same wall with Japanese ceramics and Raqqa ware in 2011 reinstallation

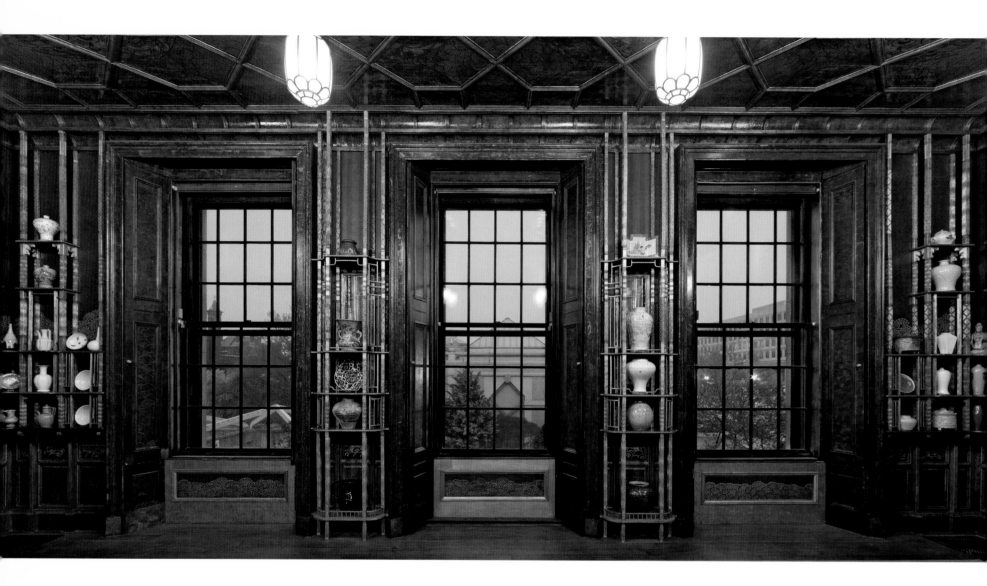

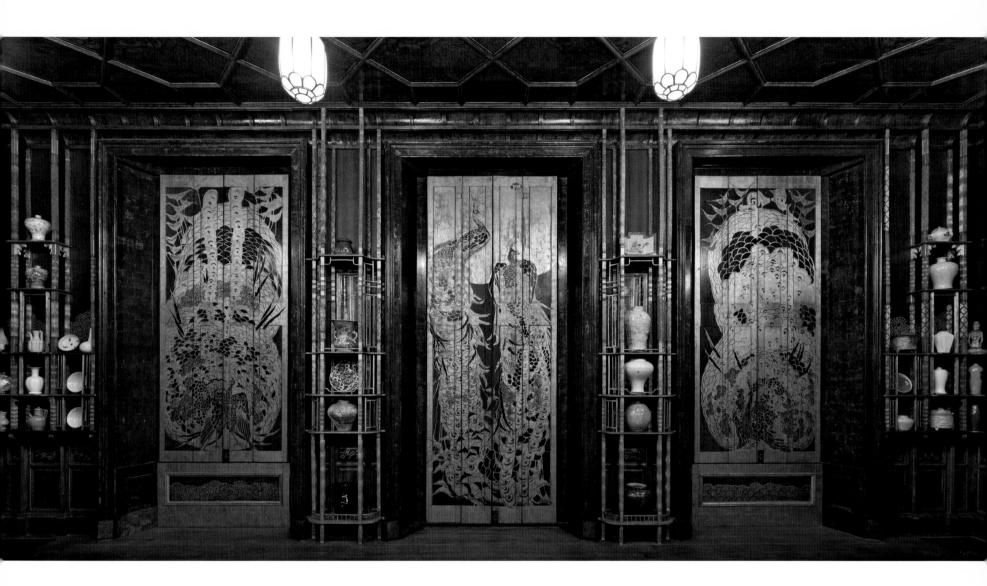

A Birthday Party in the Peacock Room

Charles Lang Freer was a lifelong bachelor, and in spite of his great wealth, he led a quiet life when he was at home in Detroit, Michigan. His neighbor and business partner, Frank Hecker, was the exact opposite. Hecker entertained a lot and had a big, energetic family. Some of his grandchildren later told *their* children stories of playing in the Peacock Room in Mr. Freer's mansion.

Betsy Graves Reyneau, who grew up in Detroit, claimed to have celebrated her twelfth birthday in the Peacock Room. Her grandfather was a prominent judge in Michigan, and she later became a famous painter. She produced a series of realistic portraits of eminent African Americans, some of which now belong to the Smithsonian's National Portrait Gallery.

In her later years, Betsy Reyneau became good friends with the poet Robert Hayden, who was also from Detroit. In the mid-1970s he was appointed the first black poet-in-residence at the Library of Congress. After hearing Reyneau's stories of her birthday party in the Peacock Room, Hayden "wandered into the Freer Gallery" and visited the room for the first time. "I stayed there as long as I could that day," he recalled, "observing its details closely, my mind full of Betsy," who had recently died. The visit inspired one of Hayden's most famous poems. Unlike the joyful memory of a childhood party, his poem is serious. It ponders the passage of time, the impermanence of life, and the enduring beauty of art.

Exotic, fin de siècle, unreal
and beautiful the Peacock Room.
 Triste metaphor.
Hiroshima Watts My Lai.
Thus history scorns
 the vision chambered in gold
And Spanish leather, lyric space;
Rebukes, yet cannot give the lie
 To what is havened here.

PREVIOUS PAGES
East wall of Peacock Room, 2011

RIGHT
North wall, 2011

Poem excerpted from "The Peacock Room" by Robert Hayden. *The Collected Poems of Robert Hayden*. Edited by Frederick Glaysher. New York: Liveright Publishing Corporation, 1985.

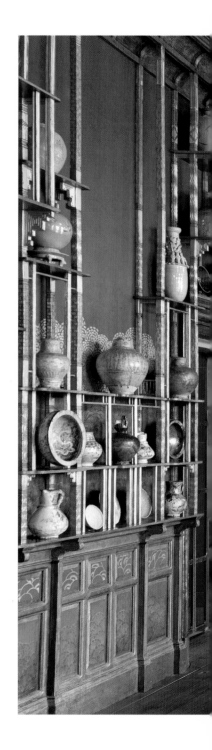

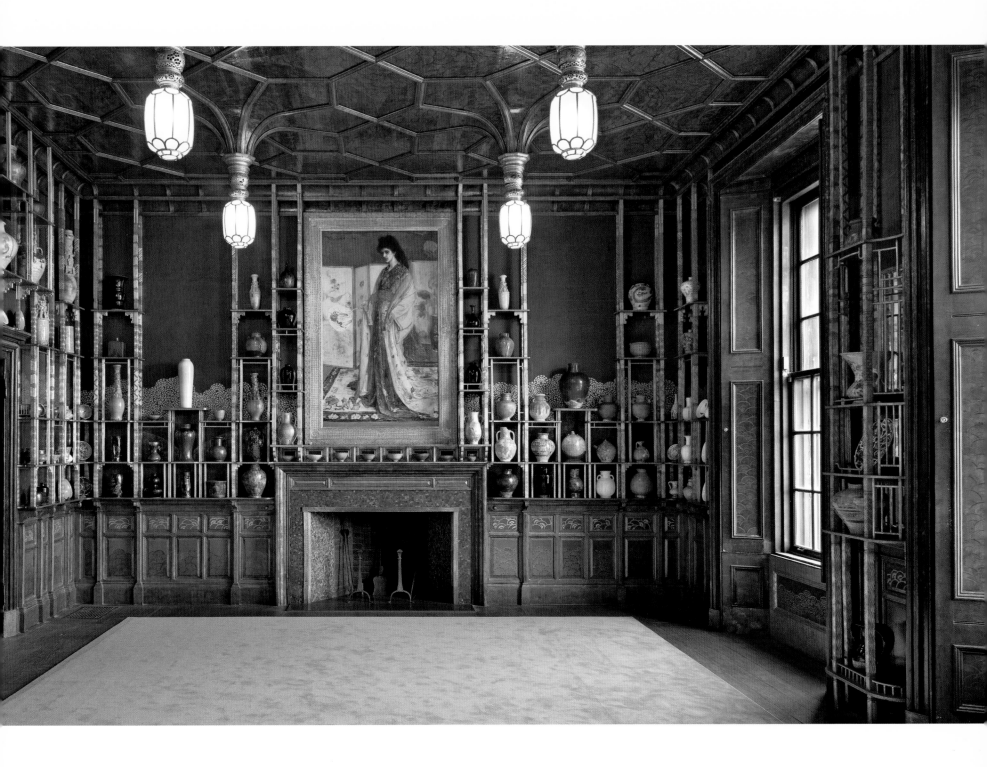

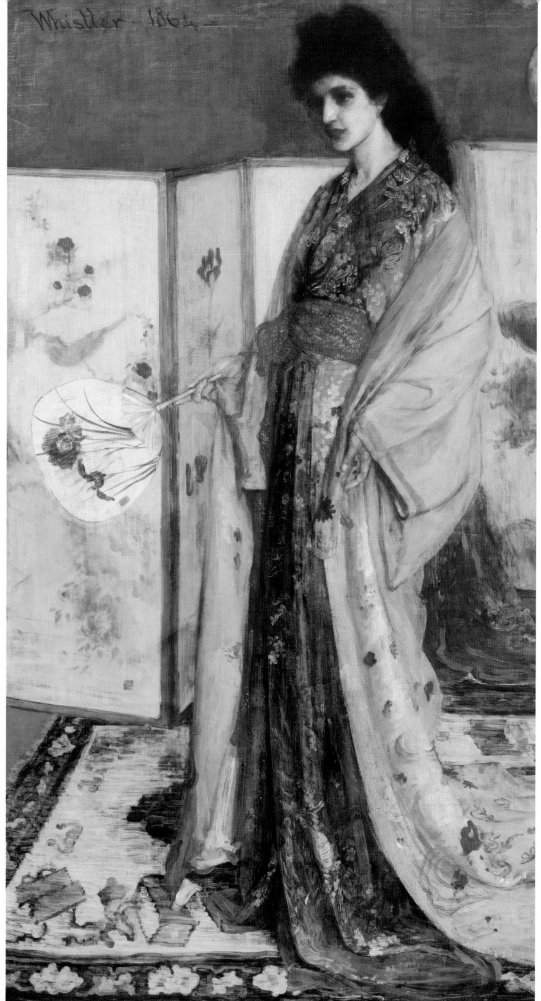

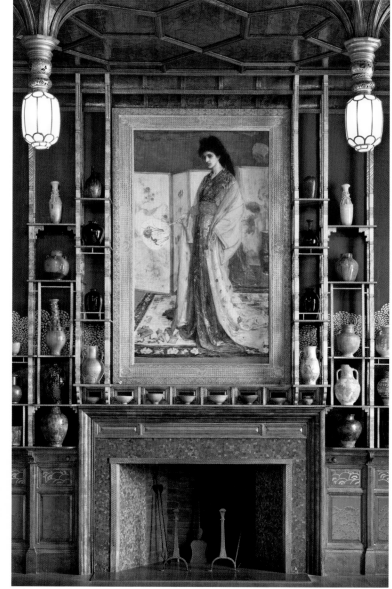

The Princess from the Land of Porcelain

La Princesse du pays de la porcelaine (The Princess from the Land of Porcelain) now reigns over the Peacock Room, but it was originally created by Whistler as one in a series of costume pictures. In the mid-1860s the artist often depicted Western models dressed in Asian robes and surrounded by porcelain, fans, and painted screens from his own collection of Chinese and Japanese objects. Produced at a time when he was trying to reinvent himself artistically and professionally, these works represent a distinct departure from Whistler's earlier interest in French realism. Here, Christina Spartali, a noted Victorian beauty, strikes a pose that recalls both the elongated figures depicted on Kangxi porcelain and the graceful courtesans of Japanese ukiyo-e prints. Unconcerned with historical or geographical accuracy, Whistler freely mingled Chinese and Japanese elements in a realm of pure fantasy, far removed from the harsh realities of life in nineteenth-century London.

When Whistler exhibited *La Princesse* at the Paris Salon in 1865, critics, who generally admired the work, described it as a "pastiche chinoise" (a hodgepodge of elements imitating a Chinese painting). The canvas changed hands several times over the next five years before it was acquired by Frederick Leyland, Whistler's first important patron. In 1875 Leyland hung the painting over the dining room mantel of his new home at 49 Prince's Gate. After Whistler saw his work displayed with Leyland's extensive collection of blue-and-white Kangxi porcelain in the summer of 1876, he maintained the color scheme of the room clashed with the palette of his painting. Leyland allowed him to make modest changes to the patterned leather wall hangings. Soon, however, Whistler's fancy took flight, and by 1877 *La Princesse* hung in an altogether different room: *Harmony in Blue and Gold: The Peacock Room*.

All of Leyland's art and porcelain was offered at auction following his death in 1892. William Burrell, a collector from Glasgow, purchased *La Princesse* at that time, but he sold it to Charles Lang Freer in 1903, shortly after Whistler's death. The following year Freer acquired the entire Peacock Room, and *La Princesse* has presided over an array of Asian ceramics ever since. Much like the room in which it hangs, *La Princesse* embodies Freer's philosophy as a collector in its imaginative, cosmopolitan representation of East-West aesthetic harmony.

LEFT
James McNeill Whistler, *The Princess from the Land of Porcelain*, 1863–65, detail and in situ

Tuning Whistler's Harmonies: Conservation in the Peacock Room

By the time Charles Lang Freer purchased the Peacock Room in 1904, the dining room had endured nearly three decades of cigar smoke and London smog. Critics who viewed the room when it was for sale routinely mentioned "brown" as one of its main colors. Whistler had described the room as "gorgeous" and "brilliant" in the letters he wrote to Frederick Leyland in 1876, but its tonalities were decidedly more muted in the early twentieth century when Freer purchased the room.

Despite the patina of grime and layers of discolored varnish—and despite the structural strain it endured in being taken apart and reassembled in London, Detroit, and Washington—the Peacock Room did not undergo significant conservation until the 1940s. John and Richard Finlayson, art restorers from Boston, dismantled the room and constructed an underlying framework for Whistler's decorations and Jeckyll's shelves. They also attempted to make cosmetic improvements by overpainting the decorations rather than by cleaning them. The team of restorers used oil paint and gold and silver leaf to retouch some surfaces, such as the shutters and the fighting peacocks. In a far cry from Whistler's original vision, they daubed greenish brown pigment on the more purely decorative areas (behind the shelves and on the wainscoting and doors), which only added to the appearance of dirty build-up.

Advances in conservation and scientific research prompted staff members of the Freer Gallery of Art to undertake a major cleaning effort from 1989 to 1992. The results revealed colors and details not seen in decades. As Linda Merrill, the curator in charge of the project, described in her study of the Peacock Room, "Dark mottled surface[s] became a shimmering greenish gold...[and] the lusterless ceiling revealed a network of peacock feathers spun across a golden ground." Inspired by the restoration of the room's original splendor, the museum began to acquire and display blue-and-white Kangxi porcelain in the room as a way to emulate, as closely as possible, Whistler's original artistic vision. Over time, however, the static display of Chinese ceramics made it difficult, once again, to *see* the room in all its variety. The Peacock Room had become a victim of its own status as a masterpiece.

To revivify the space and highlight an overlooked chapter in the room's history, in 2011 the Peacock Room was reinstalled with Freer's collection of Asian ceramics. The idea was to present the room as it looked in 1908, when it was a dynamic artistic space with many stories to tell and not an icon of art history. Opening the shutters on a regular basis (after a special protective film was installed on the windows to minimize fading) allows visitors to see the room, quite literally, in a new light, just as Whistler intended.

TOP LEFT
North wall with shelving removed during conservation, 1947

BOTTOM LEFT
Northwest wall with painted leather wall covering removed during conservation, showing new wooden substructure, 1948

RIGHT
A preliminary cleaning test of the ceiling during conservation, 1989

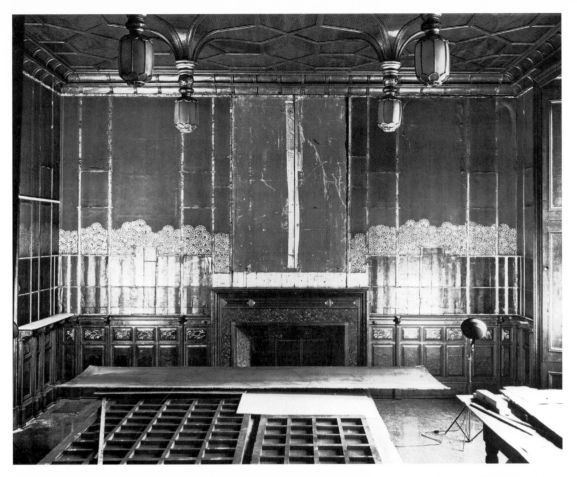

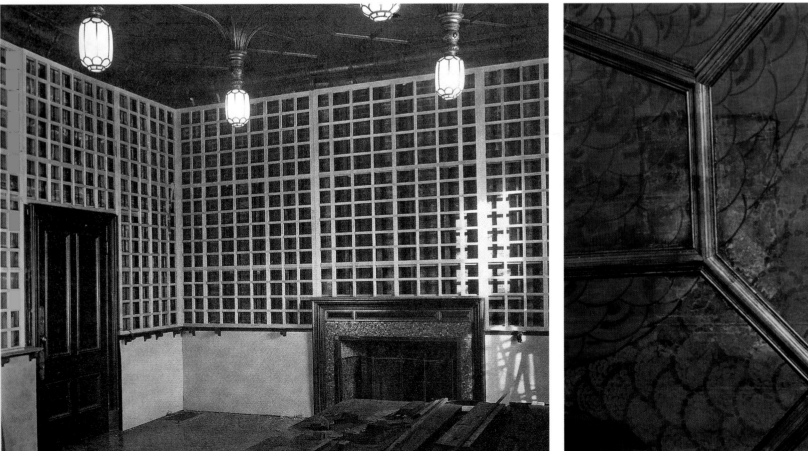

Delight in the Details

"I am nearly blind with sleep and blue peacock feathers," Whistler confided in August 1876 to Frances Leyland, the wife of his patron, Frederick Leyland. While the Leylands were out of town that summer, Whistler's imagination had soared, and the transformation of the dining room at 49 Prince's Gate was nearly complete. Inspired by the wave pattern of the leaded glass panes on the door to the butler's pantry (see next page), Whistler had begun to paint a design in gold on the blue ground of the coved cornice. The images that follow show how over time this relatively simple idea expanded into a profusion of pattern on the ceiling, dado (lower walls), and areas behind the shelving. The artist later explained that the varied motif evoked "the Eye, the Breast-feathers, and the Throat" of a peacock. "The arrangement is completed by the Blue Peacocks on the Gold shutters, and finally the Gold Peacocks on the Blue wall."

Thomas Jeckyll's original architectural design for the room was all but effaced by the artist's "glorious shimmer of gold and blue intermingled," as Mortimer Menpes, an Australian artist who studied under Whistler, described the interplay of color. Even if Jeckyll's original intention—to create a Victorian "Chinese garden pavilion," with a distinctly ribbed ceiling, pendant lights, carved walnut shelves, gilt-leather walls patterned with flowers, and views of the nearby park flanked by the tall shutters—was forever lost, the room's structure proved surprisingly amenable as a frame for Whistler's more extravagant vision. More than a century later, the Peacock Room continues to reveal its whimsical charm, encouraging visitors to take a closer look and to delight in the details.

DETAILS CLOCKWISE FROM LEFT
Carved walnut shelving spindle designed by Jeckyll and gilded by Whistler

Leaded glass door that led to the butler's pantry

Gilded fireplace andiron in the shape of a sunflower

Doorplate decorated with a lion's head medallion

Ribbed ceiling designed by Jeckyll and painted with a peacock feather design by Whistler

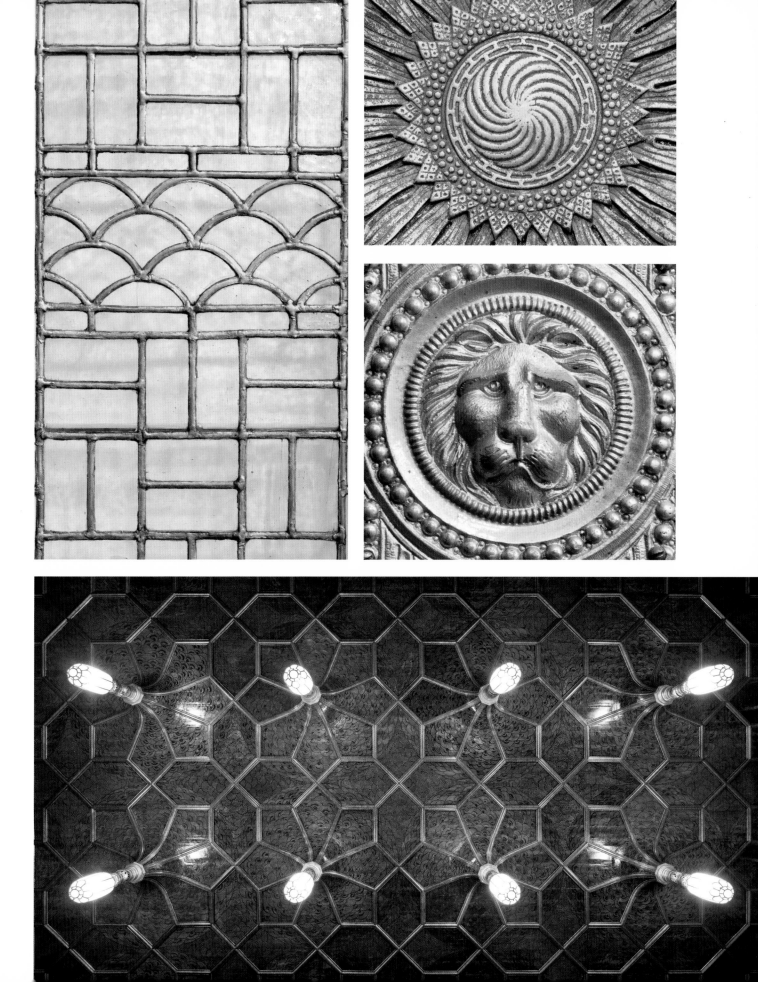

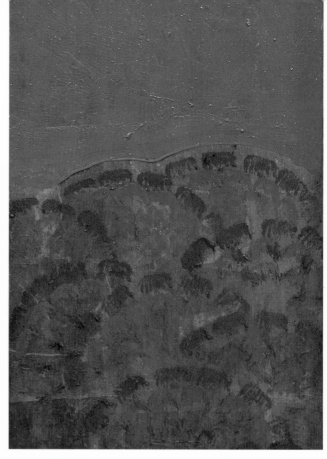

ON THESE PAGES
Details of the walls, ceiling, and shutters show
Whistler's different approaches to rendering
peacock feathers

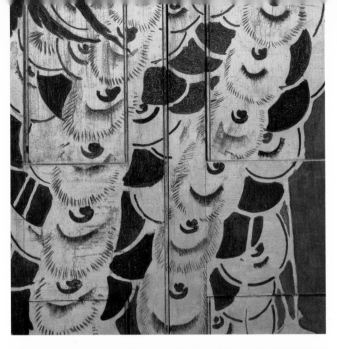

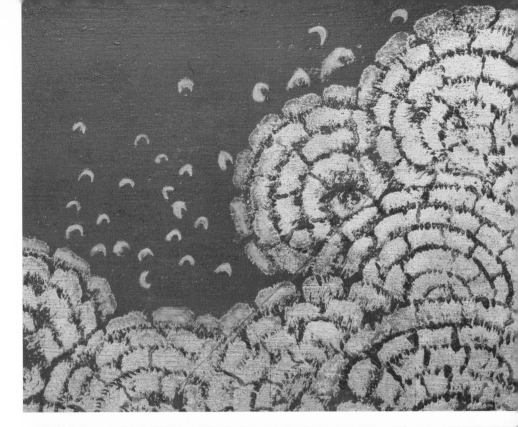

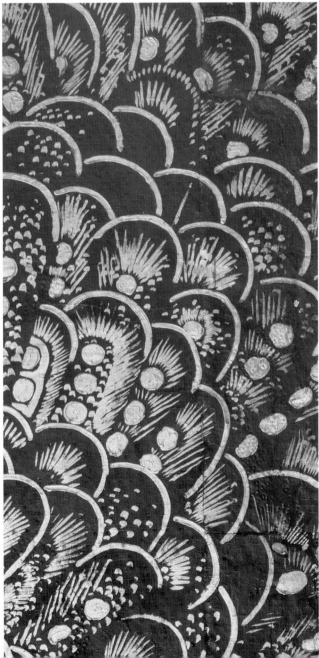

53

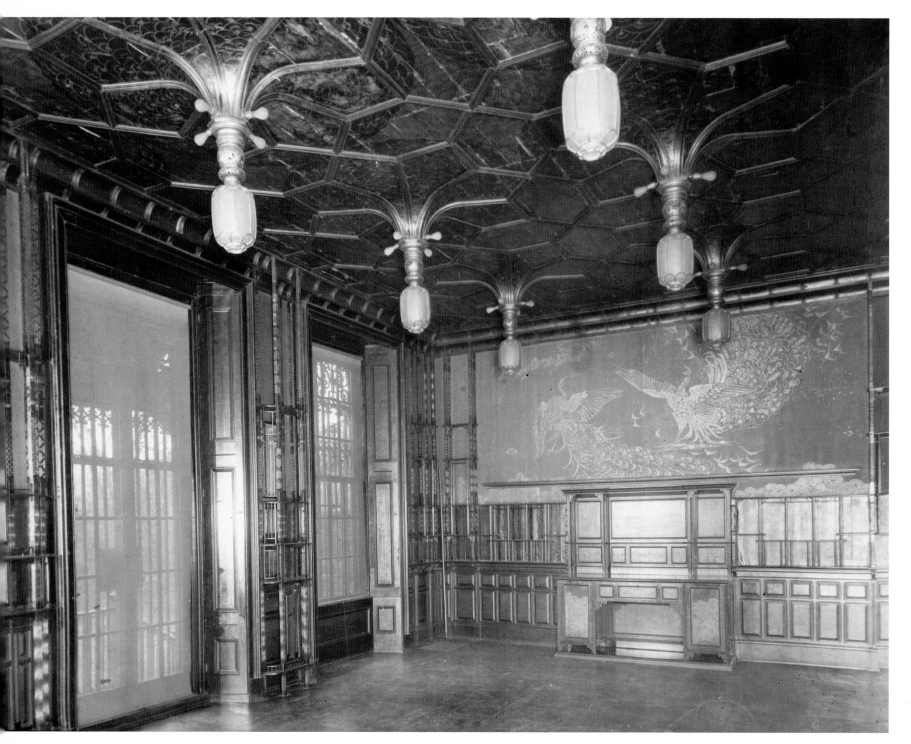

ABOVE
Empty Peacock Room in Freer's
home in Detroit, ca. 1908

Chronology

1865
James McNeill Whistler completes *La Princesse du pays de la porcelaine*.

1870
Frederick Leyland acquires *La Princesse* and begins to collect blue-and-white Chinese porcelain.

1875
Leyland hires architect Thomas Jeckyll to redecorate his dining room.

APRIL 1876
Jeckyll asks Whistler's advice on colors.

SUMMER 1876
Leyland leaves London on extended business. Whistler paints over the gilt-leather wall hangings, gilded cornices, and wainscoting. The peacock-feather design proliferates from the ceiling to the walls.

OCTOBER 1876
Leyland returns to London and quarrels with Whistler, but he ultimately agrees to pay half the requested amount and allows the artist to work in the room.

DECEMBER 1876
Whistler paints two battling peacocks on the south wall, opposite *La Princesse*.

1877
Whistler invites the press to see the Peacock Room. Leyland orders Whistler from his house, and Whistler never sees the Peacock Room again.

1887
Charles Lang Freer purchases his first works by Whistler.

1890
Freer meets Whistler in London.

1892
Leyland dies. William Burrell buys *La Princesse* at auction. Freer purchases his first Asian ceramics and his first oil painting by Whistler.

1894
Blanche Watney acquires the Peacock Room when she buys Leyland's house.

1894–95
Freer makes his first trip to Asia. (He takes other trips to Asia in 1906–7, 1908, 1909, and 1911.)

1897–1902
Freer acquires East Asian ceramics from art dealers in New York City and Boston, and he buys Raqqa ware from dealers in Paris.

1903
Whistler dies. Freer purchases *La Princesse* from Burrell.

1904
Watney sells the Peacock Room. Freer purchases it from Obach and Company in London and ships it to Detroit.

1906
Freer promises his entire art collection to the Smithsonian Institution.

1919
Freer dies. His collections, including the Peacock Room, are transferred to the Smithsonian.

1923
The Freer Gallery of Art opens to the public.

Behind the Installation

The idea of reinstalling the Peacock Room as it had looked in Detroit came from puzzling over the set of photographs by George Swain that Charles Lang Freer had commissioned in 1908. These images, now part of the Charles Lang Freer Papers in the museum archives, showed a room filled to the brim with ceramics that could not have been more different in appearance from the slick-surfaced, brightly decorated Kangxi vessels that originally ornamented its shelves. According to Freer's friend Agnes Meyer, the collector once speculated that the Victorian iteration of the Peacock Room "must have looked appalling …filled with a bewildering array of Chinese blue and white vases of different dimensions." Yet Swain's black-and-white images suggested something even more disjointed: a seemingly haphazard display rather than an intentional arrangement. Why, then, was Freer so pleased with the photographs and, indeed, with "the appearance of the objects of the shelves"? Was there something that the objects themselves could tell us that the photographs could not?

An effort to answer these questions prompted a two-year search through the storage areas of the museum to identify all of Freer's ceramics. (He had acquired more than eleven hundred Asian ceramics between 1892 and 1908.) Using Swain's photographs and elevations of the Peacock Room as a starting point, the pots in Swain's images were matched with those the collection. As each one was identified, its accession number and a thumbnail image were pasted onto a numbered shelf on the elevation.

The process of identifying the pots and reviewing the history of their acquisition revealed a great deal about Freer's aesthetic attitude. Golden brown glazes, for instance, occupied his attention in 1897, the year he acquired the little tea bowls that he later displayed on the mantel of the Peacock Room. Yet even when all the pots had been identified, an exhibition checklist created, and the elevations marked with accession numbers, Freer's intention for the Peacock Room remained mysterious. The incredible range of wares continued to be a source of nagging curatorial concern. The installation would be historically interesting, but would it be beautiful?

We only had to wait until some half-dozen pieces were placed on the shelves—the first to go in were those around the *Princess from the Land of Porcelain*—to know the effect was visually stunning. Freer had not simply been using the Peacock Room as a kind of open storage, but he had acted with genuine artistry, seeing in the medley of ceramic specimens what Whistler called "a choice selection of brilliant tones and delicate tints, suggestions of future harmonies."

RIGHT
Photographs from 1908 and elevations that guided the 2011 installation

56

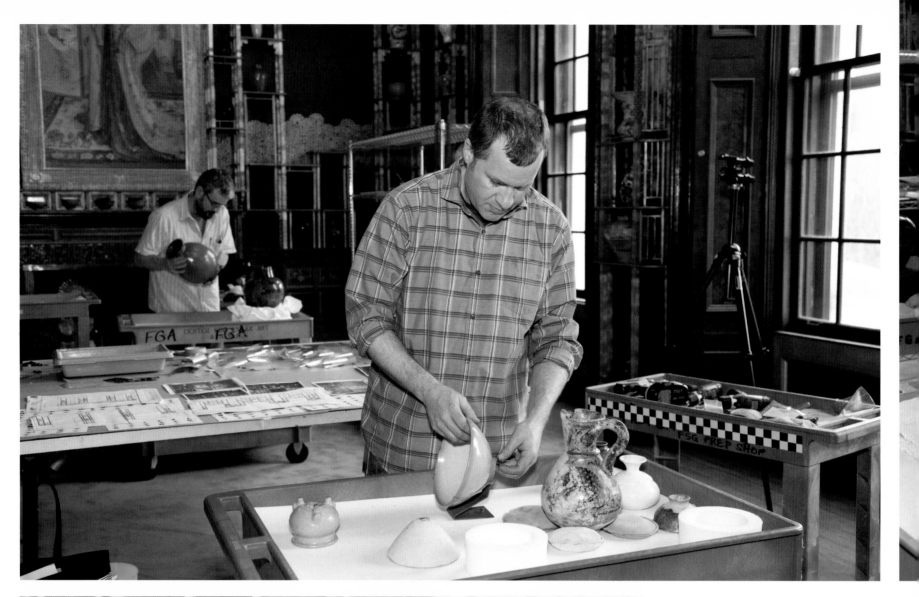

THESE PAGES
Museum staff installing
The Peacock Room Comes to America, 2011

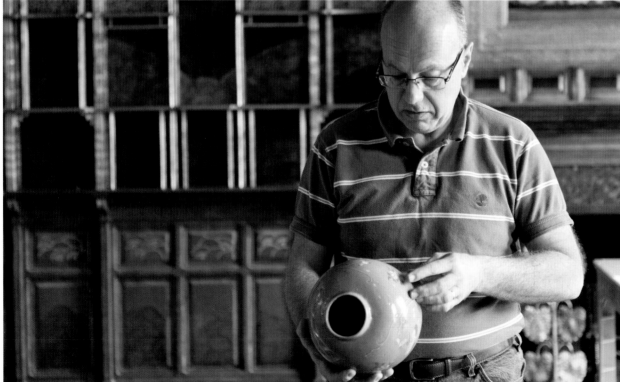

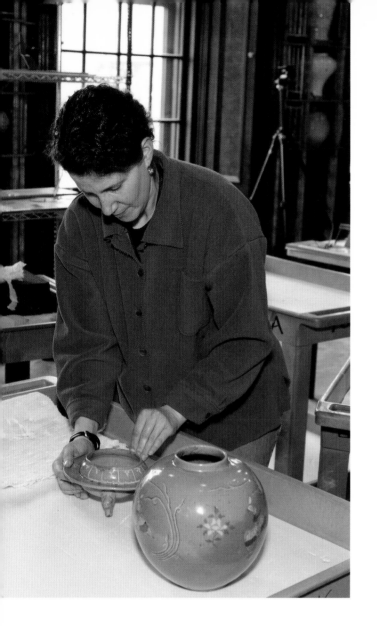

Acknowledgments

This book could not have been completed without the creative talent of many colleagues at the Freer Gallery of Art. Julian Raby, museum director, and Massumeh Farhad, chief curator, deserve special thanks for their support of American art at a museum better known for its Asian collections. The author would especially like to acknowledge Nancy Eickel for her thoughtful and careful editing of this text and all of the interpretive material connected to the exhibition *The Peacock Room Comes to America*; Jane Lusaka, Karen Sasaki, and particularly Adina Brosnan McGee for a book design that reflects the lavishness of the subject; John Tsantes, Neil Greentree, and Robert Harrell for the gorgeous new photographs of the Peacock Room and its contents; Louise Cort, curator of ceramics, for her invaluable help in identifying the ceramics; Maya Foo for her help with archival and image research and for many other details too numerous to name; and the Honorable Max N. Berry for his enthusiastic support of this project. Tim Kirk, Christina Popenfus, Teak Lynner, John Piper, Ellen Chase, and Jenifer Bosworth also are owed thanks for meticulously reinstalling the Peacock Room to its appearance in 1908 and allowing visitors to see it in a new light.

This publication was made possible by a generous gift from the Mr. and Mrs. Raymond J. Horowitz Foundation for the Arts, Inc.

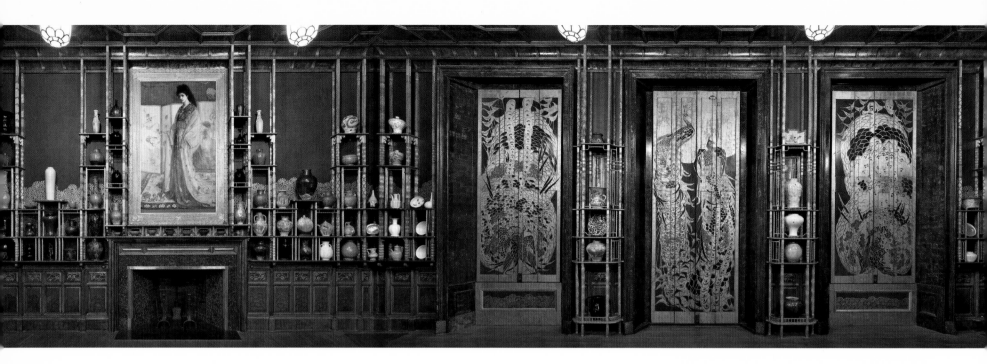

Credits

Unless otherwise noted, all works are the gift of Charles Lang Freer and are in the collection of the Freer Gallery of Art. Archival materials are part of the Charles Lang Freer Papers in the Archives of the Freer Gallery of Art and Arthur M. Sackler Gallery. Additional credits can be found on the copyright page and in the image captions.

PAGE 7

Top: Thomas R. Way, *Portrait of Whistler*, 1879. Lithograph on paper. F1901.188.

Bottom: James McNeill Whistler, *Arrangement in Black: Portrait of F. R. Leyland*, 1870–73. Oil on canvas. F1905.100.

PAGES 10–11

Left: Rendering by Peter R. Nelsen, 1997.

Center: Photograph by H. Bedford Lamere.

Right: Photograph by George R. Swain

PAGE 14

Bottom: Photograph by George R. Swain.

PAGE 16

Top: James McNeill Whistler, *Venus Rising from the Sea*, ca. 1869–70. Oil on canvas. F1903.174.

Bottom: James McNeill Whistler, *Nocturne: Blue and Silver—Bognor*, 1871–76. Oil on canvas. F1906.103.

PAGE 17

Photograph by George R. Swain.

PAGE 22

Top right: Pitcher. Syria, Raqqa, 12th–13th century. Stone-paste with degraded turquoise glaze. F1905.77

Bottom left: Jar. Mesopotamia, Parthian period, 1st–3rd century. Earthenware with alkaline glaze. F1903.190.

Bottom right: Jar with two handles. Syria, Raqqa, 12th–13th century. Stone-paste with degraded turquoise glaze. F1905.286.

PAGE 24

Photograph by P. Dittrich.

PAGE 25

Top: Jar. Syria, Raqqa, 12th–13th century. Stone-paste painted under glaze. F1904.143.

PAGE 26

Top left: Planter. China, Henan province, Linru kilns,

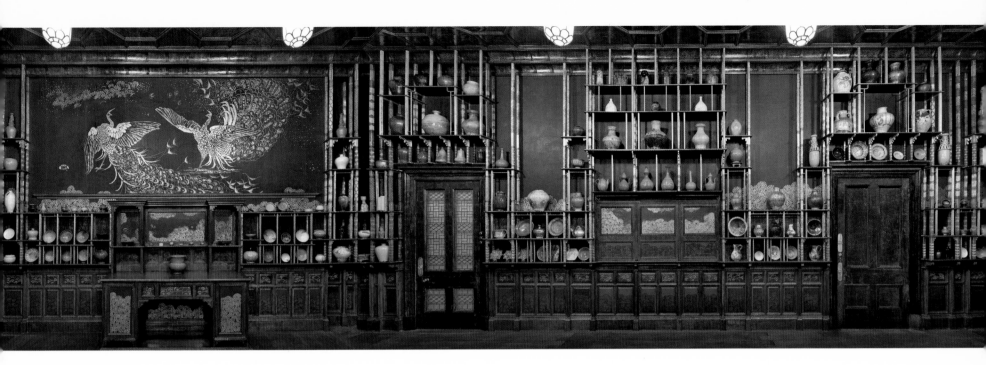

Jun ware, Northern Song dynasty, 11th–early 12th century. Stoneware with Jun glaze. F1907.38.

Bottom left: Dish with molded decoration. China, Guandong or Jiangsu province, Shiwan or Yixing ware, Ming or Qing dynasty, 17th century. Stoneware with Jun-style glaze. F1905.306.

Top right: Vessel in shape of a lidded alms bowl. China, Jiangxi province, Jengdezhen ware, Qing dynasty, 18th–19th century. Stoneware with Jun-style glaze. F1898.44.

Bottom left: Bottle. China, Guandong province, Shiwan kilns, Qing dynasty, 17th–19th century. Stoneware with rice-straw glaze. F1898.46.

PAGE 31
Right: Photograph by George R. Swain.

PAGE 33
Top left: Bottle. Japan, Hiyamizu kiln, Satsuma ware, Edo period, 18th century. Stoneware with cobalt pigment under clear glaze. F1892.26.

Bottom left: Tomb jar. China, Eastern Han dynasty, early 1st–3rd century. Earthenware with copper-green lead-silicate glaze. F1905.87.

Top right: Ewer. Korea, Jeolla-do province, Gangjin or Buan kilns, Goreyo period, 12th century. Stoneware with celadon glaze. F1907.286.

Bottom right: Sake bottle. Japan, Kiyamizu kiln, Satsuma ware, Edo period, 18th century. Stoneware with cobalt pigment under clear glaze. F1905.41.

PAGE 38
James McNeill Whistler, 1885. Inscribed, "To Charles L. Freer—a un de ces jours" (till we meet again). Photogravure attributed to Mortimer Menpes.

PAGE 46
James McNeill Whistler, *The Princess from the Land of Porcelain*, 1863–65. Oil on canvas. F1903.91.

PAGE 49
Department of Conservation and Scientific Research, Freer Gallery of Art and Arthur M. Sackler Gallery, Smithsonian Institution.

THIS PAGE
Panoramic view of *The Peacock Room Comes to America*, 2011

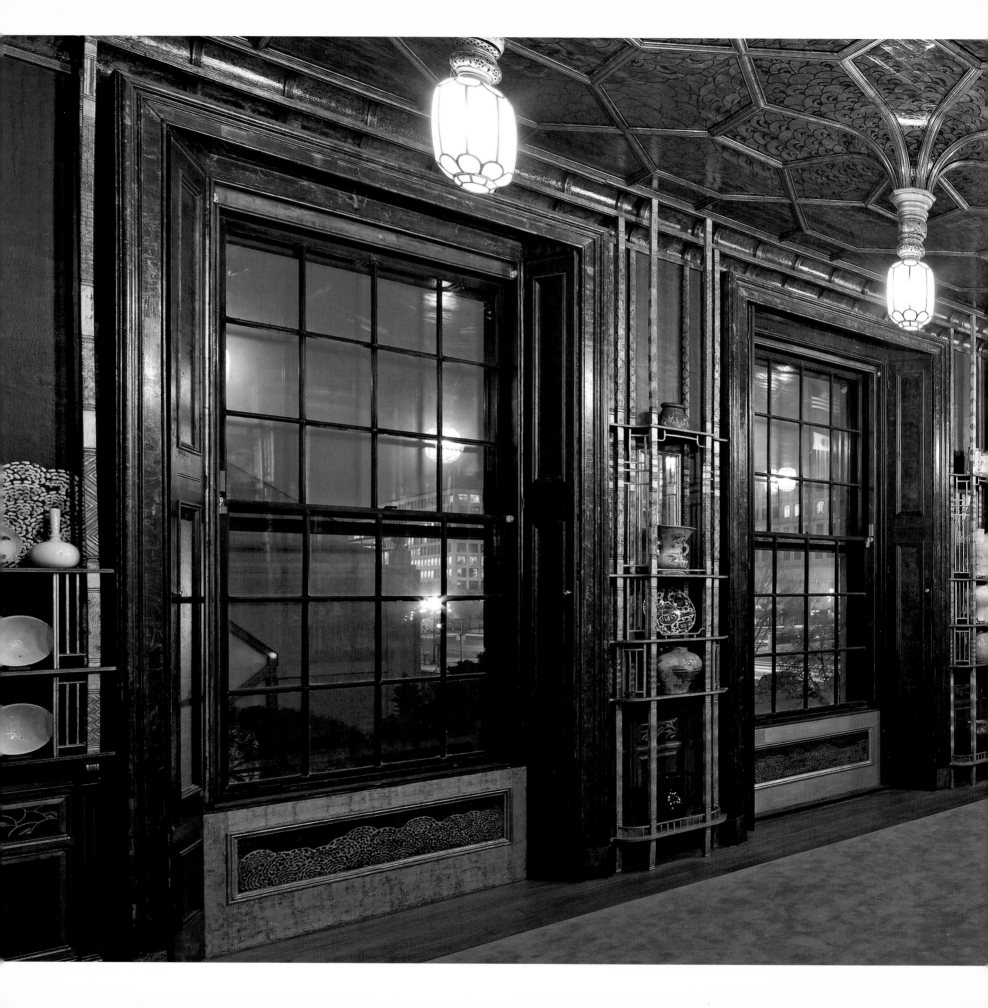

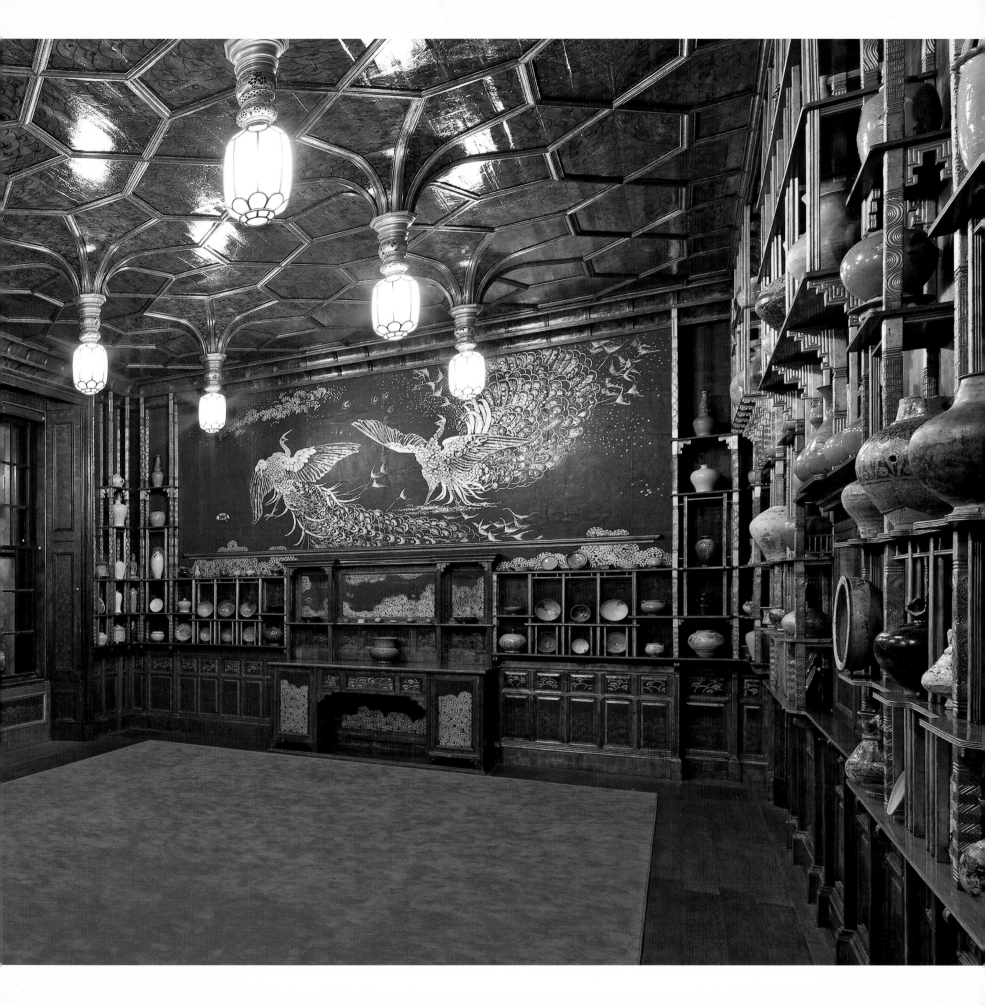

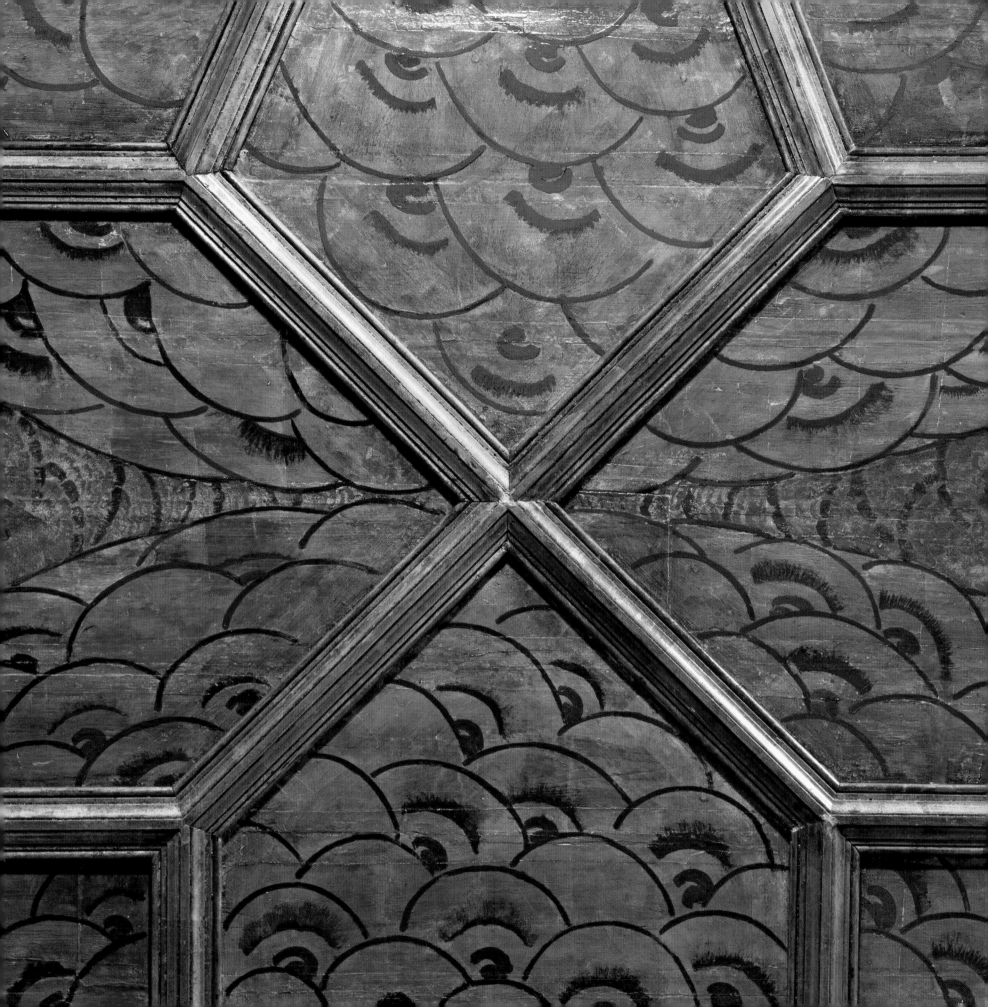

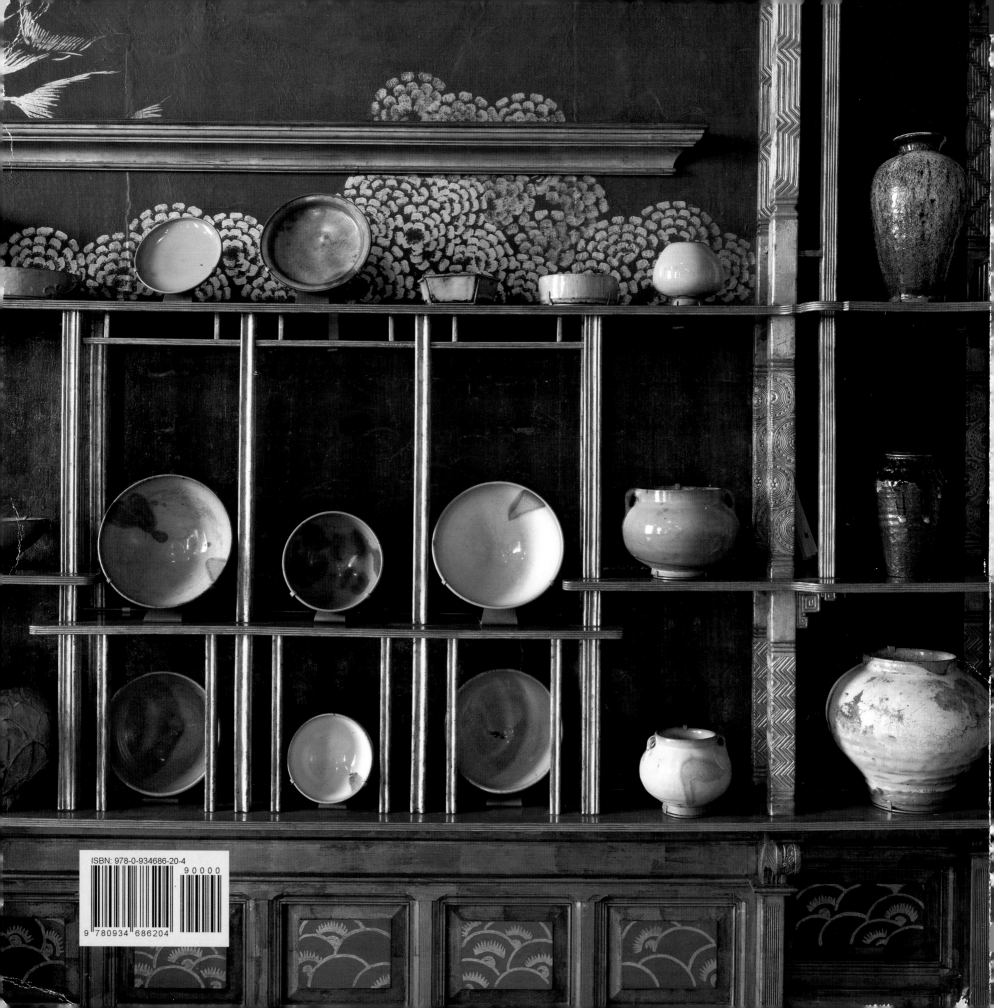